A

Guidebook

TO THE

Hunterian Art Gallery

OF THE

University of Glasgow

Supported with funds from
Glasgow District Council's Festivals Budget

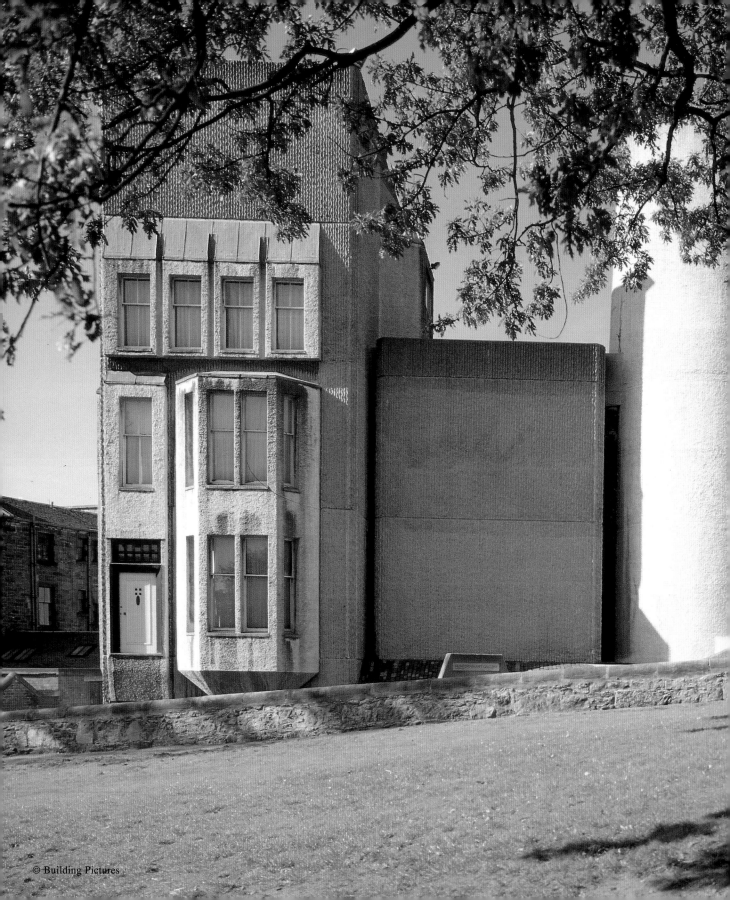

Acknowledgements

This guidebook fills a long-recognised gap in our publications programme. It replaces *Glasgow University's Pictures*, compiled by the late Professor Andrew McLaren Young and his staff for a major exhibition at Colnaghi's in London in 1973. That publication, only recently out of print, was designed to spearhead the University's campaign for funds to build its new Art Gallery. While giving valuable information ~ freely drawn on in this work ~ it could not, of course, guide visitors around a building and displays yet to be created.

This new publication provides an introduction to the formation and housing of the University's art collections and a brief "walk-round" guide to the contents of the Gallery itself. These accounts are followed by more extensive notes on 24 artists and their works, accompanied by full-page plates.

In compiling this guide I am indebted to many people. My curatorial colleagues Martin Hopkinson and Pamela Robertson have provided both new research information and critical appraisal of the text. Elizabeth Hancock, temporary guide-lecturer, gave valuable insights into public opinion, and assisted in the drafting of the individual notes to the plates. More generally, I am grateful to many previous authors in compiling the summary biographies of the artists selected. Modern information technology ~ and of course the skills to use it ~ have enabled a high standard of typesetting and design to be achieved "in house" by June Barrie

and Stephen Perry. All photography, unless otherwise credited, has been undertaken by Trevor Graham and staff in the Photographic Unit, and is the copyright of Glasgow University. I am grateful to Douglas Kattenhorn and to Anne Dick of Building Pictures for creating and supplying the remainder. Several works illustrated remain in copyright, and I would like to thank Sir Eduardo Paolozzi, William Turnbull, Doug Cocker and the estates of J.D. Fergusson, Stanley Cursiter and Joan Eardley for their kind permission to reproduce them free of charge. The quality of the reproductions, and of the printing of the guide, is due to the skilled hands of J. Thomson Colour Printers Ltd.

There are very many other people to thank. These are our visiting public, who found time in 1989 to complete a questionnaire inviting them to consider the scope of a future guidebook and requesting their personal "top ten" works of art to illustrate it. As far as possible, we have incorporated their views, and are thus indebted to our public in the creation of this work.

Finally it must be said that a fully-illustrated colour guide of this length could not have been achieved easily from our own resources. Our grateful thanks are therefore due to Glasgow District Council, for the financial support provided through its Festivals Budget.

C.J. ALLAN
DEPUTY DIRECTOR

A Brief History of the Art Collections

The history of the Hunterian Art Gallery as a separate entity is brief indeed, for it first opened to the public in 1980. Significant aspects of the collections, however, have been cared for by the University of Glasgow for nearly two centuries. They were previously housed in our parent body, the Hunterian Museum.

When it first opened to the public in 1807, the concept of a public museum was, if not a novelty, then certainly a rarity. Glasgow University had the honour to build and maintain the first museum and gallery, not only in Glasgow, but in Scotland as a whole.

The foundation of this museum, and the stimulus it provided for further development, was entirely due to the abilities and generosity of Dr William Hunter, a former student. While art formed only one aspect of his diverse collections, his involvement in it was far from superficial. Further information will be found on pp. 34 and 40. His interest in art may first have been stimulated by Dr Francis Hutcheson, who taught aesthetics at Glasgow when Hunter was a student. Hutcheson's presence may also have encouraged Glasgow's first art school, for the Foulis Academy was operated by brothers Robert and Andrew Foulis, the University's printers, in rooms rented within the University from 1753 to 1776.

Hunter's excellent example was not immediately followed. Glasgow rose to be a major world centre in

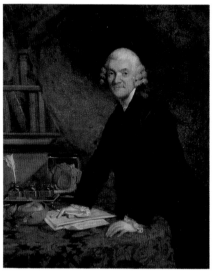 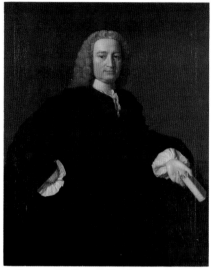

Sir J. Reynolds, **Dr William Hunter**, c.1787-9 A. Ramsay, **Dr Francis Hutcheson**, c.1740-45

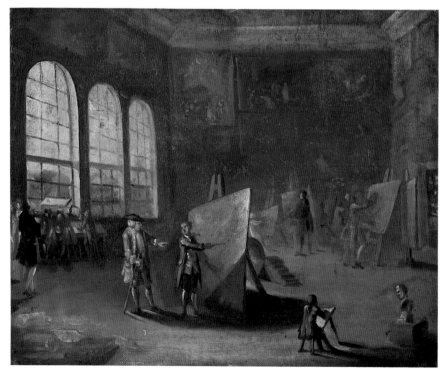

David Allan, **Interior of the Foulis Academy**, c.1762

4

trade and industry in the 19th century, and art patronage rose with it. However, the University's art collections remained relatively static apart from the steady flow of commissioned portraits of Principals and Professors.

The most significant new developments took place from the 1930s onwards, well over a hundred years after Hunter's original impetus. The first of these was the gift of the major part of James McNeill Whistler's estate by Rosalind Birnie Philip in 1935. This large influx of paintings, drawings and prints by a single major artist was rapidly followed by two further collections of the greatest diversity, made up almost entirely of prints. The bequest (1940) of Professor W.R. Scott, and the gift (from 1939) and bequest (1948) of Dr James McCallum, together with an endowment for future purchases, gave to the University a holding of virtually all the great European artists who had set their hands to printmaking from the Renaissance onwards.

Nor was this all, for at the same time the University acquired the estate and the house of another great artist, the architect and designer Charles Rennie Mackintosh. 78 Southpark Avenue, once his home, was purchased on the death of his patron and long-time guardian of his artistic estate, William Davidson, in 1945. Davidson's executors, his sons Hamish and Cameron, presented all the furniture designed

Wm. Stewart, **Interior of the first Hunterian Museum**, mid 19 C.

by Mackintosh remaining in the house in 1946, and took steps to arrange the transfer of the residual estate of some 600 drawings and designs from Sylvan MacNair, Mackintosh's nephew, to the University in 1947.

Thus in the space of little more than a decade, the University's art collections advanced numerically from about 300 works to more than 10,000. The post-war development of the collection, though recently facilitated by modest purchase funds and the grant-aid that such funds can

attract, has largely followed this well-established pattern of private generosity in gifts and bequests. For example, the nucleus of Hunter's Old Master collection has been complemented by the paintings presented and bequeathed by Miss Ina Smillie (p. 30), the Trustees of William Cargill (pp. 36, 42, 44) and Dr Charles Hepburn. In the field of 19th-20th century Scottish art the holdings have been largely created by the gifts of Sir Daniel Stevenson, Gilbert Innes (p. 66) and Professor Alec Macfie (pp. 56, 58, 64). The latter formed his comprehensive collection of Scottish painting with the express intent of transferring it to the University, while Innes encouraged the acquisition of contemporary art, leaving funds from which, for example, the Eardley (p. 70) was bought. At the same time, the status of the print collection led the Trustees of Dr Leonard Gow to present his comprehensive collection of drypoints by Sir Muirhead Bone in 1965.

Housing the Collections

In choosing the form of a classical temple for the original museum in 1807, William Stark was first to adopt this building type for museum use in Britain. Subsequently, the Old College Lands were sold for railway development, and the first museum was demolished. On the University's move to Gilmorehill in 1870, a wing of Sir Gilbert Scott's new building was allocated to the museum. The Neo-Gothic architecture was not ideally suited to displaying paintings, and there was certainly no room to present adequately the huge influx of works of art from the 1930s and 1940s. Various inelegant expedients were devised for paintings, while the print collection was eventually housed separately in the obscurity of a house in Bute Gardens. The Mackintosh house and its contents, in use as a professor's residence, could only be seen by prior appointment.

It became clear in the 1950s that an adequate home for the art collections would need to be developed and would have to be funded from the University's private resources and from public appeal. Despite presiding over a huge new building programme for all Universities in the 1960s and early 1970s, art galleries were definitely not, in the view of the University Grants Committee, a priority for government support. Andrew McLaren Young, the University's first Professor of Art History, channelled much of his energy into promoting a new Gallery. The architect selected was

Interior of the present Hunterian Museum, c.1975, before removal of the art collections

William Whitfield, of London, first commissioned to build the new University Library. He and Professor Young then examined many of the latest developments in Britain, Europe and the U.S.A. Post-war advances in museology indicated that new galleries should be equipped not merely for public access and display, but also for storage and conservation, with a high level of security and environmental controls (temperature, relative humidity and lighting levels) to aid long-term preservation.

The design created by Whitfield Partners aimed to fulfil all these needs, and was a fine piece of contemporary architecture as well. Construction began in 1973. However, the funding of the building, exacerbated by contractual delays and rapid inflation, was a source of worry till the end, for only a second public appeal, by Principal Sir Alwyn Williams, finally secured the full cost. The Main Gallery was opened by Sir Hugh Casson on Commemoration Day ~ 16th June, 1980 ~ with the Mackintosh House, Print Gallery and other areas following in September 1981.

For the first time the strengths of the University's art collections could be fully appreciated. We trust you will enjoy what is now available.

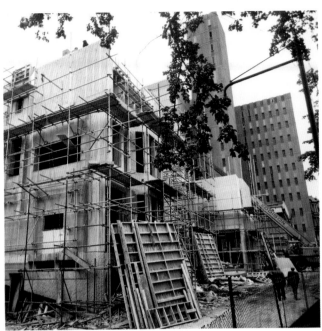
The Gallery under construction, 1974

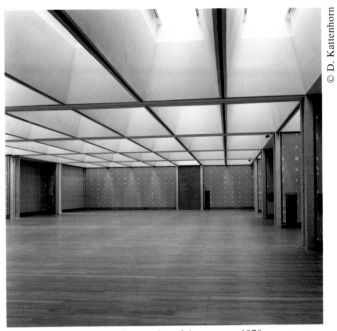
The Main Gallery before the erection of the screens, 1978

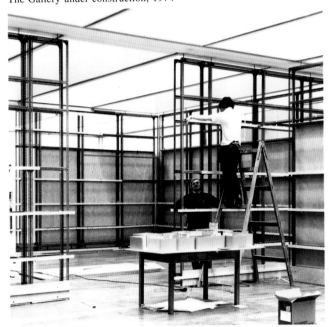
The Main Gallery screens under construction, 1980

The Main Gallery roof lights, from the Library

Publications and Information

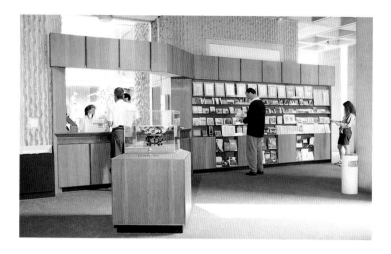

The Bookshop and Enquiry Desk is in the Entrance Foyer. Here the visitor can choose from a variety of postcards, cards and slides of many works of art in the collections, as well as full-colour posters from past exhibitions. The shop has an expanding range of reproductions (framed and unframed) of Mackintosh flower drawings and watercolours, and a unique Portfolio of six Mackintosh Architectural Drawings. There is also a range of books and catalogues, all relating to the Gallery's collections. At the foot of the adjacent staircase is an extensive display of current leaflets and posters from other Arts organisations.

Some recent publications

Mackintosh Flower Drawings
Pamela Robertson, 1988, ISBN 0-85261-226-5

The Mackintosh House Guidebook
Pamela Robertson, 2nd Edn, 1990, ISBN 0-85261-186-2

Charles Rennie Mackintosh: The Architectural Papers
Pamela Robertson (Ed.), Pub. White Cockade Publishing, 1990, ISBN 0-9513124-1-3

Prints & Printmaking
Chris Allan, 1990, ISBN 0-904254-08-9

James McNeill Whistler at the Hunterian Art Gallery
Martin Hopkinson, 1990, ISBN 0-904254-11-9

Souvenir Guide to the Hunterian Museum and Art Gallery,
Lawrence Keppie (Ed.), 1990, ISBN 0-904254-14-3

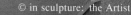

THE MAIN GALLERY

The Main Gallery contains the finest of the University's collection of paintings. Access to it is through the four cast-aluminium doors by Sir Eduardo Paolozzi, which form such a striking feature of the Entrance Foyer. They were created deliberately to integrate art within a functional aspect of architectural requirements, the happy result of an informal discussion on the subject between the sculptor and the architect, William Whitfield. Commissioned with substantial help from the Scottish Arts Council, the reliefs were cast and assembled in 1977. Within the gallery the collection is arranged in broadly historical order, at least in so far as the earliest paintings are seen first, and contemporary art is at the far end. The divisions reflect the size and scope of particular strengths in the collection, but there is no set route among these free-flowing spaces.

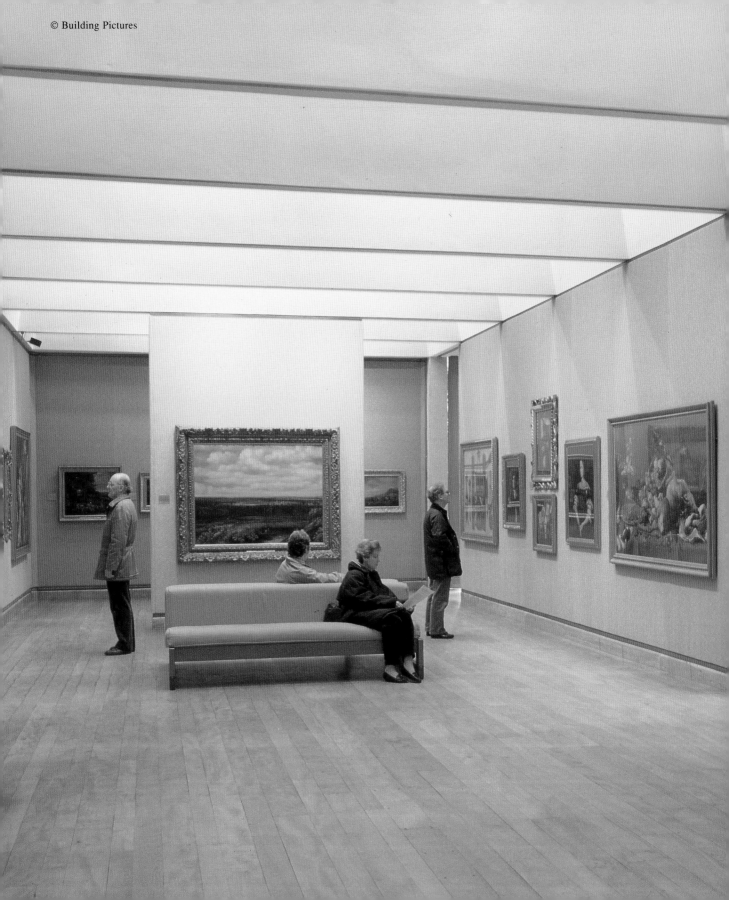

16th-17th Century Paintings

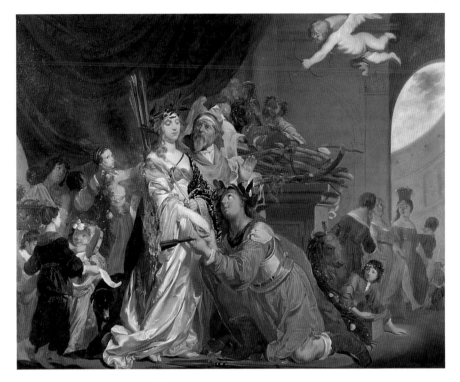

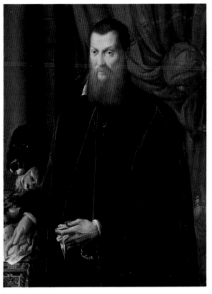

Michele Tosini, **Portrait of a Gentleman**, c.1560

Hans Horions, **The First Meeting of Theagenes and Charicleia**, mid 17C.

The first bay contains 16th-17th century works, the earliest being the fine Italian Mannerist *Portrait of a Gentleman* (c.1560) by Michele Tosini and the *Lady with a Parrot* (1564) by the Dutchman Anthonis Mor. Directly opposite the entrance hangs Rembrandt's *Entombment* (p. 26) while on the centre screen the *Panoramic Landscape* of Koninck (p. 28) dominates the room. Both are masterpieces of 17th century Dutch art, acquired by William Hunter.

Different aspects of 17th century still-life painting, by De Vos (p. 24) and Leemans (p. 30) can be compared on the long screen wall, while opposite are two unusual subject pictures. Cossiers' *Martyrdom of St Catherine* was purchased by the University before the bequest of Hunter's collection, having been used as a teaching aid for art students in the Foulis Academy. *The First Meeting of Theagenes and Charicleia* represents one of the most obscure subjects in the annals of art history. No less obscure is its author, Hans Horions, for this flamboyant and colourful work is one of only four paintings that can definitely be attributed to him.

For the technically minded, De Vries' *Architectural Fantasy* reveals an interesting first thought about the perspective of the roof to the right (the overpainting having become more transparent with age). The French artist Stella creates a highly finished effect by painting on the unusual support of slate in his *Holy Family*. Oil painters often sketched on a prepared paper and the economy of means used to create the *Boy Singing*, attributed to Bernini, is noteworthy.

From this bay two routes, via 18th century art or via 19th century French and Scottish art, lead to the Whistler display.

18th–Early 19th Century Paintings

In the next bay Ramsay's portrait of Hunter (p. 34) is hung beside the latter's most celebrated acquisitions, three early works by Chardin (p. 32) and a portrait of one of his most valued patients, *The Countess of Hertford* by Roslin. Adjacent are three paintings by Stubbs (p. 40), whom Hunter commissioned to record from life animals new to science then entering the menageries of the aristocracy. Opposite are a group of 18th century British portraits including fine works by Reynolds (p. 36), Ramsay and Raeburn. *Mrs Tracy Travell* by Ramsay is particularly delicate.

Late 18th and early 19th century Scottish works are displayed beyond the screen. These include Hamilton's *Mary Queen of Scots* (p. 38) and a fine bust of the artist by Hewetson. Romanticism in Scotland is exemplified in the powerfully expressive *Russians Burying their Dead* by Scott. Among the smaller works, Allan's *Foulis Academy*, referred to in the introduction, shows the interior of this early Glasgow art school.

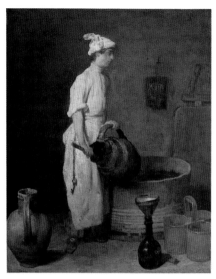

J.S. Chardin, **The Cellar Boy**, 1738

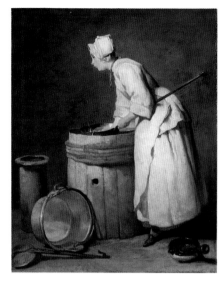

J.S. Chardin, **The Scullery Maid**, 1738

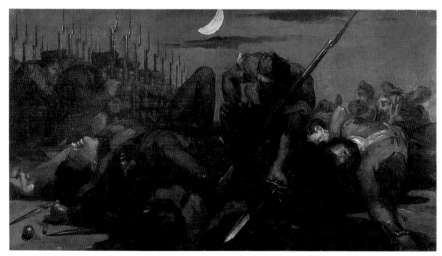

David Scott, **Russians Burying their Dead**, 1831-2

19th Century French and Scottish Paintings

In the small area between the Old Masters and the Whistler display will be found a fine flower piece by Fantin-Latour (p. 50), a close friend of Whistler in their early days, together with other 19th century French paintings by Corot (p. 42) and Boudin, and the Impressionists Pissarro (p. 44) and Sisley (p. 52). Rodin (p. 54) and Whistler (p. 46) were colleagues in organising international exhibitions.

Opposite the French paintings is a group centred on the work of the Scot, William McTaggart (p. 48). His pioneering development of open-air painting is akin to, concurrent with, but entirely independent of the Impressionist movement in France.

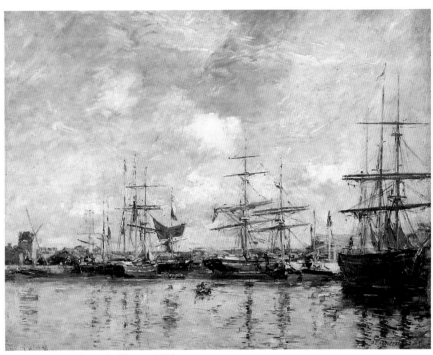

Eugène Boudin, **Port du Havre**, 1888

Wm. McTaggart, **Roslin Castle, Autumn**, 1895

William McTaggart, **The Golden Grain**, 1894

13

The Whistler Collection

From these works we move to the extensive display of paintings by James McNeill Whistler (1834-1903). Whistler was an American who, having studied in Paris, settled in London. While making regular visits to the Continent, he never returned home. He became one of the most progressive forces of the period. His ideas led him to emphasise the formal and purely visual qualities of art, and he was deeply opposed to the Victorian taste for descriptive finish and elaborate story-telling. Throughout his career he was on friendly terms with the leading French artists and writers. In his younger days he was on intimate terms with Fantin-Latour (p. 50), and subsequently with Manet, Degas and the poet Mallarmé.

This international outlook and his insistence on painterly craft endeared him to the Glasgow artists ~ the 'Glasgow Boys' ~ who encouraged the University to confer an honorary degree on Whistler in 1903, a few months before his death. The subsequent acquisition of Whistler's artistic estate, given (1935) and bequeathed (1958) by Rosalind Birnie Philip, his sister-in-law, has made the Hunterian a major centre for the study of this charismatic artist.

In this bay, and the next, Whistler's development may be traced from student works, painted in Paris in the 1850s, to his last paintings. His fascination with Far Eastern art found expression in his collection of oriental ceramics and in

General View © Building Pictures

Screen with Old Battersea Bridge, 1871-2

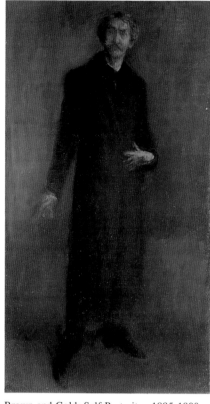

Brown and Gold: Self Portrait, c.1895-1900

his own work. This is particularly apparent in the *Cartoon for the Peacock Room* and the *Screen with Old Battersea Bridge*. Both also reflect his interest in interior decoration, as does the *Butterfly Cabinet*, a collaboration with his friend E.W. Godwin, which now takes pride of place among other

items of furniture owned by Whistler.

Many of the grand full-length portraits, some sombre, some fiery in effect (p. 46) are of members of his immediate family. They are interspersed with intimate and delicately painted shop-fronts and interiors, figure subjects and smaller portraits,

Sketch for 'The Balcony', 1867

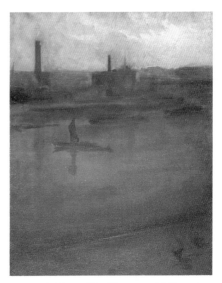
Grey and Silver: The Thames, c.1872

The Bathing Posts, Brittany, c.1893

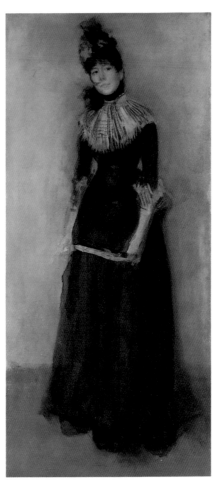
Rose et Argent – La Jolie Mutine, c.1890

The Priest's Lodging, Dieppe, c.1890

notably of children. There are in addition examples of the famous Thames night-pieces that he called *Nocturnes*, and of his minute, luminous, and bracing seascapes.

Whistler had many pupils and admirers; a number of works by Moore, Menpes, Sickert, Starr and Henry have been acquired and hung amongst his own work to demonstrate his influence. The contents of the estate also extended to his pastels, watercolours, drawings, etchings and lithographs, from which exhibitions are drawn only for short periods, due to their sensitivity to light. A selection of his palettes and painting materials is permanently displayed, and includes the extraordinary long-handled brushes that he had made to his own requirements.

19th–20th Century Art

Beyond the Whistler Collection are displays of late 19th century Scottish painting ~ in which the Glasgow Boys predominate, and of early 20th century Scottish painting ~ in which the Scottish Colourists do likewise.

The Glasgow Boys: The senior Glasgow Boys, Guthrie, Paterson and Walton, acknowledged Whistler and the later French realists such as Bastien-Lepage among the sources for their painterly handling of direct observation. The Boys achieved international status by the turn of the century, being represented in major exhibitions across Europe. Younger members, such as Henry, Hornel (p. 56) and Pringle (p. 58), combined their observations with an increasing use of decorative patterning.

The Scottish Colourists: While the next generation of Scottish artists were in turn influenced by the direct approach of the Boys in their youthful works, first-hand contact with Paris made a more lasting impression. While held in high regard in Scotland, it is only recently that the Colourists, J.D. Fergusson (p. 62), Leslie Hunter (p. 64), S.J. Peploe and F.C.B. Cadell (p. 66), have become more widely appreciated. The bold, flat colouring and firm outlines of Matisse and the *Fauves*, and the achievements of Cézanne, were variously drawn on by the group. All four however had sufficient individuality to forge styles unmistakeably their own.

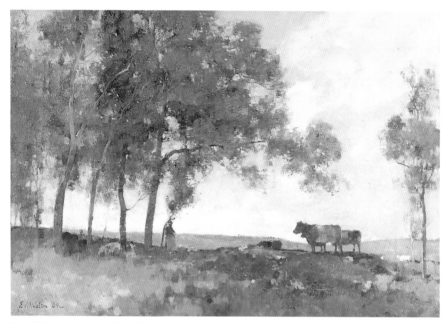

E. A. Walton, **Autumn Sunshine**, 1884

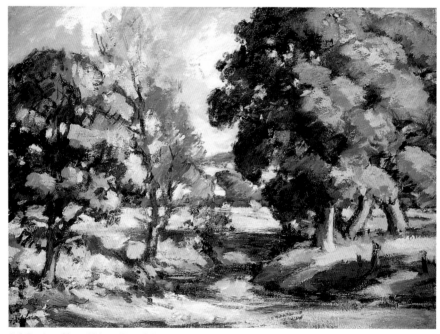

S. J. Peploe, **New Abbey, Dumfriesshire (Summer)**, 1925

Art of the Recent Past: The final bays present a selection of post-war British art, with an emphasis on the work of Scots such as Davie, Gear, Philipson and Eardley (p. 70), and, among younger artists, Mooney, Howard and McFadyen. There are also pure abstract paintings by Cina, Golding and Kidd, a conceptual piece by Latham, and an early example of European Pop Art by Télémaque. A complex web of ideas and influences has contributed to a range of alternative concepts being developed in contemporary art, perhaps greater than in any previous time.

The Side Gallery:

Returning through the Main Gallery, this smaller space links the entrance foyer to The Mackintosh House. It is normally used for contemporary art, or to extend exhibitions held in the Print Gallery. The curved outer wall of the spiral staircase forms a dominant architectural feature, and a large sculpture in ash and cedar was specially commissioned for this site from Doug Cocker, with the support of the Henry Moore Foundation. During the time needed to develop and make the piece (1986-7) the artist's style underwent a radical change. The title *The Mad Carpenter's Last Moondance* refers to the sculptor's late-night struggles to align and assemble the complex components of this work in the cramped space of a studio in which quite different ideas for sculpture mutely awaited development.

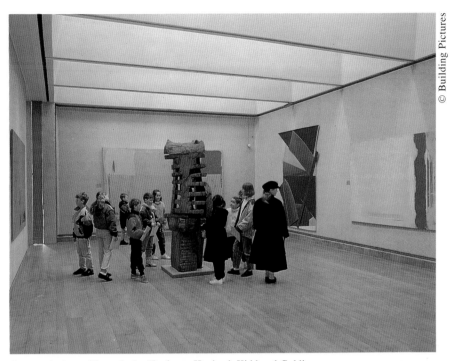

A general view with works by Herdman, Hoyland, Kidd and Golding

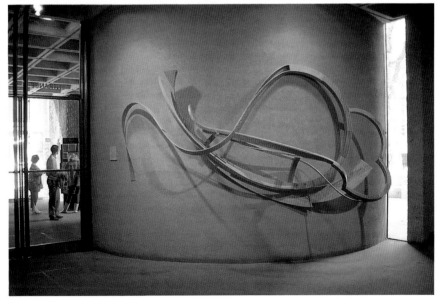

Doug Cocker, **The Mad Carpenter's Last Moondance**, 1987, in the Side Gallery

The Mackintosh House and Estate

A detailed guide to the House is separately available, and the following is a brief summary only. From the Side Gallery access is via a pair of doors containing panels designed by Mackintosh for the Ingram Street Tea Rooms, Glasgow. The House, reconstructed in shuttered concrete, contains the principal rooms of Mackintosh's original home at 78 Southpark Avenue ~ some 70 metres away ~ which had to be demolished in 1963.

The visitor enters through an Information Room which gives extensive details of the history of the project and occupies the position of the original cloakroom and maid's room off the hall. Thus the first impression is not that which applied in Mackintosh's day, when all visitors would have entered from the front door in the hall.

The original house at 78 Southpark Avenue was carefully measured, and all fittings ~ doors, windows, fireplaces etc. ~ removed prior to demolition. The new construction is identical in its fenestration and orientation, so that the same effects and direction of light are created. While the rear kitchen, and the bedroom extension over it were not recreated, the staircase and principal rooms are in the correct sequence, and are decorated and furnished as they were. With one or two exceptions, where items known to be missing have been substituted with copies, all the furniture and fittings are original.

Entrance to 78 Southpark Avenue in 1963

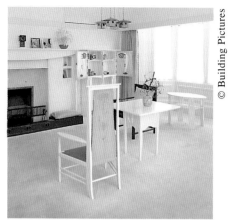
The Drawing Room

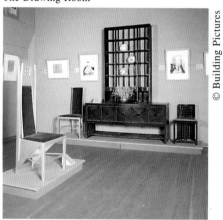
The Mackintosh Gallery

Of course the project could have been achieved more simply and economically by creating a series of three-sided room settings. However, Whitfields' reconstruction of the house offers the visitor the unique experience of the sequence of spaces and decor which Mackintosh himself created from the interior of a standard town house of the 1850s.

In the area originally occupied by the bathroom and attic, not recon-structed, but gained from the door on the upper landing, a split-level gallery area has been created to display other aspects of the Mackintosh Estate, and additions to the collection which are not pertinent to the house itself. These include posters, stained glass and a room setting from Mackintosh's last interior commission, the Guest Bedroom at 78 Derngate, Northampton, of 1919.

Clock, 1905

The Fort, c.1924-6

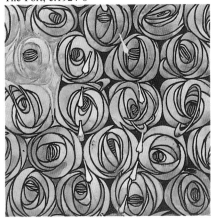

Textile Design, c.1916-23

Queen's Cross Church, 1897

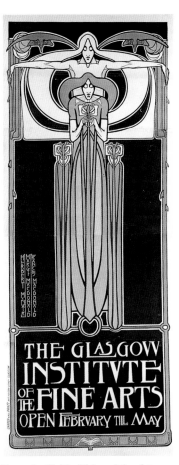

Poster by H. MacNair and the sisters
F. and M. Macdonald, c.1895

The University owns the residual estate of Mackintosh, made over to it by the surviving heir, Sylvan MacNair, in 1947. This comprises some 600 drawings and designs which cover all aspects of Mackintosh's career. Apart from what is publicly displayed in the House and Gallery, it is possible to research the reserve collection by prior appointment.

It should be remembered that Mackintosh, now celebrated internationally as a genius of modern design, was virtually forgotten at the time when his lifelong supporter William Davidson secured care of the estate, and Davidson's sons Hamish and Cameron made over the furniture and other contents of 78 Southpark Avenue when the University purchased it. One aspect of the reassessment of Mackintosh's achievements has been the discovery that his designs have continuing validity in the contemporary context. Since 1972 the University has been associated with the intelligent reconstruction of his designs for furniture pioneered by Cassina of Italy and subsequently adopted for Mackintosh metalwork by Sabattini Argenteria. Their use of appropriate modern technology has encouraged the worldwide diffusion of Mackintosh's concepts of design.

The Print Gallery

Returning to the Entrance Foyer, the Print Gallery will be found on the floor above, up the spiral staircase. Please ask to use the lift if access is a problem for you. At c. 20,000 items, the Hunterian possesses Scotland's most comprehensive collection of Western printmaking, containing the works of most major artists from the 15th century to the present day. Additions in this field are an important part of the Gallery's acquisitions policy. The Print Gallery shows thematic exhibitions from this resource on a temporary basis. While it must be closed from time to time between exhibitions, we aim to offer a more extensive and more varied sequence of exhibitions on the subject than any other gallery in Scotland.

To assist in the interpretation of any given exhibition, there is a permanent display of printmaking techniques which aims to help you to understand the variety of procedures that have been used to create the different sorts of prints you will see, and the qualities that can be expected of each particular medium.

It might be of interest to make some general points about this exhibition area. Firstly, the lighting level is quite low, and you should allow a minute or two to allow your eyes to adjust. Control of light is essential because all works of art on paper ~ watercolours, drawings or prints ~ are gradually destroyed by light. Secondly, the showcases contain a prismatic diffuser to bend

Mackintosh Textile Designs, a past Print Gallery exhibition

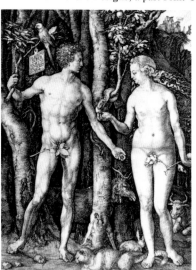

Albrecht Dürer, **Adam and Eve**, 1504

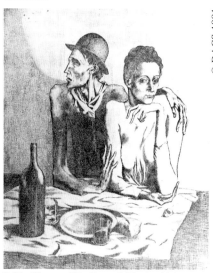

Pablo Picasso, **The Frugal Meal**, 1904

the light source, coupled with mirrors below to reflect back stray light, ensuring even illumination. Thirdly, the protecting glass is angled to avoid reflections, and bring the viewer to within a few inches of the works on show.

The Prints and Drawings Collection as a whole is housed in a non-public area in the basement. Visitors are welcome to consult particular aspects of the collection, but this must be by prior appointment in writing.

The Sculpture Courtyard

Returning to the Entrance Foyer, *Large Siren* by William Turnbull signals the entrance to the outdoor Sculpture Courtyard, enclosed between the Gallery and the adjacent University Library. The courtyard was designed as a setting for large contemporary works. The Gallery has relied on loans, for example *Noon* by Gavin Scobie, from the Scottish Arts Council and *Paul's Turn* by Sir Anthony Caro, from the artist. Subsequently *Aje* by Jeff Lowe and *Rio* by Sir Eduardo Paolozzi have been acquired by purchase and gift respectively. The character and content of the courtyard will change gradually as further acquisitions are made and planting is fully established.

While intended for contemporary sculpture, the courtyard also houses an early example of Mackintosh's architecture. The *Lantern and Finial,* designed to crown the dome of Pettigrew and Stephen's Glasgow department store, was salvaged on demolition in 1973, and has been restored to its original appearance.

The most recent outdoor acquisition is *Diagram of an Object* by Dhruva Mistry, a contemporary variation on the enduring sculptural theme of a seated mother and child. This bronze was commisioned with the support of Glasgow District Council in 1990, and acts as a landmark for the Gallery outside the entrance in Hillhead Street.

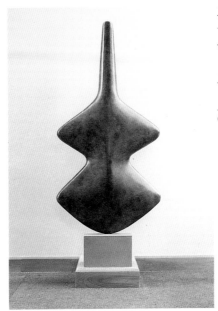

William Turnbull, **Large Siren**, 1986

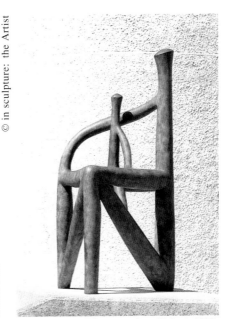

© in sculpture: the Artist

Dhruva Mistry, **Diagram of an Object**, 1990

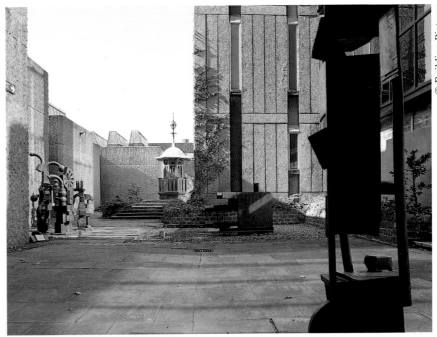

© Building Pictures

The Sculpture Courtyard with (from left) works by Paolozzi, Mackintosh, Caro and Lowe

Works of Art in Other Locations

Within Sir Gilbert Scott's main University building, the north staircase to the **Hunterian Museum** is hung with 18th century history paintings. Gavin Hamilton (p. 38) is represented by *Hector's farewell to Andromache* (1775-6) from his cycle of Homeric paintings which were pioneer examples of the Neo-Classical style, and by *Dawkins and Wood discovering Palmyra* (1758), an equally heroic portrait group commemorating one of the significant archaeological events of the period, on loan from Dawkins' descendants.

Within the Museum, Sir Francis Chantrey's *James Watt* (1830-33) and Hans Gasser's *Adam Smith* (c.1867), both excellent examples of 19th century portrait sculpture, are integrated within a comprehensive display on the history of Glasgow University. Adjacent is the Coin Gallery, founded on the outstanding collection of coins and medals formed by William Hunter.

In the **West Quadrangle**, not far from the stairway to the Museum, is the wind-powered abstract work by the sculptor George Rickey, *Three Squares Gyratory,* commissioned in 1972.

Other works, principally portraits, are less accessible, but information on public tours of the University is available from the **Visitor Centre.**

The **University Library** contains magnificent illuminated manuscripts and illustrated books, housed in its Department of Special Collections.

Hans Gasser, **Adam Smith**, c.1867

George Rickey, **Three Squares Gyratory**, 1972

Pisanello, **Francesco Sforza**, c.1441

William Hunter's library consisted of over 650 manuscripts and 10,000 early printed books. Subsequent additions include the Dougan archive of the early history of photography. Many of the finest illuminated manuscripts are reproduced in a recent publication, *The Glory of the Page*, available at the Library.

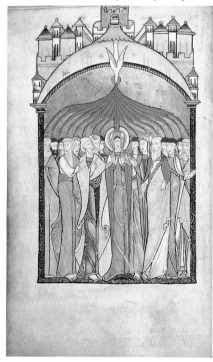

The Hunterian Psalter, English, c.1170

Plates

Paul de Vos
Flemish: 1596-1678

Still Life with Dead Game and Fruit
Oil on canvas: 119.4 x 202.6 cm.
Bequeathed by Dr William Hunter, 1783

De Vos, the younger brother of the portraitist and history painter Cornelis de Vos, was born in Hulst and trained with the little-known Antwerp painters, Denis van Hove and David Remeeus. Far more significant for his artistic formation was the fact that his sister, Marguerite, married the most skilful Flemish painter of still-lives and hunting pieces of the day, Frans Snyders. De Vos became a Master of the Antwerp Guild of Painters in 1620. Like his brother-in-law he had a close association with Peter Paul Rubens, who stood as godfather to one of his children. From 1626 until Rubens' death he worked on a number of commissions with the great Flemish master, particularly in Spain decorating the hunting lodge of Torre de la Parada in 1636-7 as well as the palace of Buen Retiro. He also painted many pictures for Philippe d'Arenberg, Archduke of Arschot and other leading members of the Spanish Court at Madrid as well as executing designs for tapestries. De Vos' greatest achievements are his exuberant hunting scenes full of bounding and tumbling dogs, but he was also well known for his still-lives and assemblages of weaponry and musical and scientific instruments. Scholars still have difficulty in disentangling works of his authorship from those of his brother-in-law, Snyders.

Still Life with Dead Game and Fruit is a 17th century Flemish pantry scene, in the tradition of kitchen subjects developed in Antwerp in the late 16th century. Traditionally ascribed to Frans Snyders, its present attribution rests on its resemblance to a painting in the Prado, Madrid, inscribed as by de Vos. Both artists worked in the large studio practice of Sir Peter Paul Rubens, and were equally subject to his powerful influence on Flemish art. The work would have been created for display in a spacious dining room. It appears to have been cut down at both sides, perhaps to fit a particular space above a door or fireplace. It was probably presented to Hunter by Lord Beauchamp, Earl of Hertford. His mother, the Countess of Hertford, was a patient and friend of Hunter, who owned her portrait by Roslin, also here exhibited.

The painting is both a hunting trophy and a frank celebration of the bounty of Nature. Wild boar, roebuck, heron and partridge, the spoils of the chase, are combined with a harvest of fruit and vegetables. Grapes, apples, pears, plums, quince, blackcurrants, apricots, lemon, globe artichoke and asparagus can all be seen, the majority tumbled onto the table from a cornucopian wicker basket. A huge lobster lies on a Chinese export porcelain dish, and behind it a silver-gilt tazza is laden with sweetmeats and decorated with artificial flowers.

The composition, bathed in a shaft of light which illuminates the otherwise shuttered room, is animated by assured brushwork and vivid local colour. Even the corpses seem to contribute to this sense of flowing rhythmic movement, while the continuity of life is suggested by the introduction of the enquiring dogs, and the squabbling yellow-headed parrots.

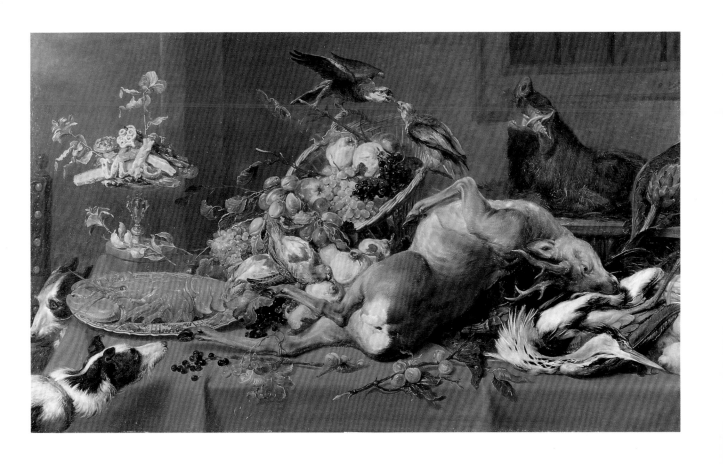

Rembrandt Harmensz van Rijn

Dutch: 1606-1669

The Entombment of Christ

Oil on panel: 32.2 x 40.5 cm.
Bequeathed by Dr William Hunter 1783

Rembrandt was born in Leiden, the son of a miller. Early studies at Leiden University were abandoned for training as a painter. Apprenticed to Jacob Swanenburgh, he subsequently studied (1624-5) with Pieter Lastman in Amsterdam, who exerted a significant influence on his early style. Returning to Leiden he set up in company with Jan Lievens, but in 1631-2 he settled for the remainder of his life in Amsterdam. He soon became one of the most fashionable portrait painters in Holland. His marriage to the wealthy Saskia van Uylenburgh from 1634 to 1642 brought greater prosperity and contentment, but her death, his passion for collecting and unbusinesslike attitudes led to bankruptcy in 1656. His art became more introspective as his technical freedom developed and the circle of his patrons diminished. He lived in reduced circumstances in the Jewish quarter, finding a ready source of models for his biblical paintings. Rembrandt is undoubtedly one of the greatest of artists, valued for the psychological penetration of his portraits (there are some 60 self-portraits alone, painted over 40 years), his technical brilliance, his mastery of light and shade, and the great humanity which he brought to bear in interpreting both Old and New Testaments. His abilities as a draughtsman and etcher were also outstanding and his prints established his reputation across Europe. During the period of his prosperity Rembrandt was avidly sought as a teacher, and maintained a large studio in which many leading Dutch artists received training.

The Entombment of Christ, neither signed nor dated, falls in style quite early in Rembrandt's career. There are conflicting views as to when it was painted, but recent opinion dates it to the mid 1630s. It is a sketch, not a finished work, though its purpose remains a matter of conjecture. Rembrandt subsequently adapted the composition to a vertical format for a picture commissioned for Prince Frederick Henry of Orange (Alte Pinakothek, Munich), which was painted between 1636 and 1639. Hunter bought it for 12 guineas in 1771.

This episode is told in all the Gospels though with little factual detail of the tomb itself. According to Matthew, Joseph of Arimathaea: "took the body, wrapped it in a clean linen sheet, and laid it in his unused tomb, which he had cut out of the rock". The setting therefore offers great scope to the artistic imagination. Here the action takes place within a large cave, entered from the upper right. Joseph of Arimathaea supports the head of Christ; his companion, Nicodemus, who brought myrrh and aloes to preserve his body, takes the feet. The Virgin, kneeling, with John the Apostle behind her, are to the left of the body. The crouched figure on the right is probably Mary Magdalene. Further shadowy mourners, dimly lit by their lanterns in the background, increase the emotional tension of the composition.

This is an outstanding piece of painting, combining, without any jarring inconsistency, free and summary brushwork with areas of detailed finish, most notably the unflinching realism of Christ's head. Some parts, such as the Virgin Mary, are created with a buttery impasto, while in others the brown ground of the panel is exploited to create an underlying unity. The main group is dramatically lit from below, by the candle shielded in Mary's hand.

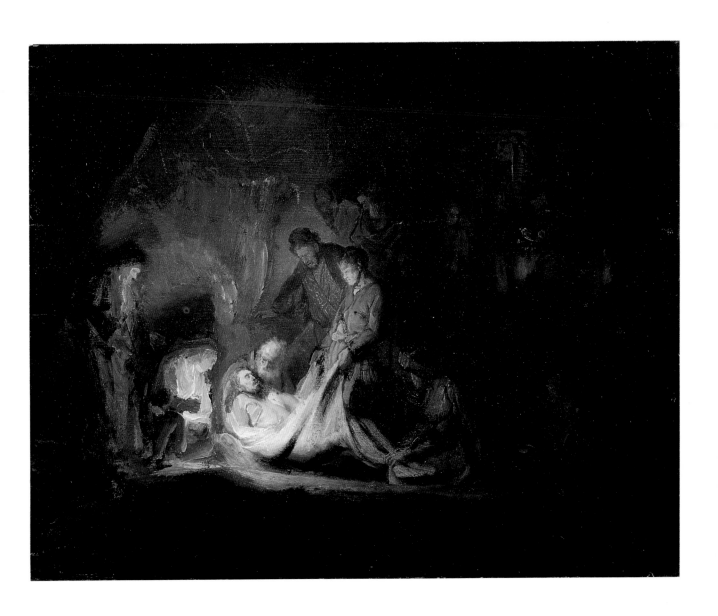

Philips de Koninck

Dutch: 1619-1688

Panoramic Landscape

Oil on canvas: 112.0 x 155.0 cm.

Bequeathed by Dr William Hunter, 1783

Koninck was born in Amsterdam and is believed to have been a pupil of Rembrandt (p. 26), as well as studying landscape painting under his brother Jacob. His drawings have often been confused with those of Rembrandt. Koninck painted *genre* (scenes of everyday life), history paintings, and portraits ~ regarded as of no special distinction ~ as well as landscapes. The best of these landscapes rank among the finest produced in Holland and are remarkable both for their panoramic breadth and for the painterly conviction with which they transform the mundane Dutch countryside. Koninck was almost certainly inspired by the now rare works of Hercules Seghers, who equally exerted a powerful influence on Rembrandt's approach to landscape. Koninck was not prolific as a painter, and seems to have produced few works in later life. Like so many Dutch artists of the period, which was intensely competitive, he did not rely on art as a sole source of income, being responsible for managing the market-boats between Amsterdam and Rotterdam.

Panoramic Landscape, neither signed nor dated, was probably painted around 1665. The first Old Master that Hunter bought, for 16 guineas in 1755, was descibed as "a capital work by Rembrandt." Though not correctly attributed until well into last century, the imaginative sale catalogue was at least accurate in part. It was and remains "a capital work".

Modern debates on the virtues of 'abstraction' versus 'representation' seem unimportant when confronted with this work. The basic composition involves no more than the abrupt division of the canvas into two slightly unequal horizontal bands of light and dark, earth and air. Over this basis, Koninck proceeds to weave a magician's brush across his canvas, conjuring up the prospect of many distant miles of land, water, trees and settlements, under the spread of a vast dappled sky. The rich complexity of this recession into the distance is in part conveyed by a very summary technique. Look closely at the dark band of woodland across the middle distance and you will see only the barest indications, dabbed directly into the brown ground. This ground, used to prepare the entire canvas, is also exploited to impart a subtle warmth to the sky. The farmhouse which nestles amid the little plantation is conveyed with a few outlining brush-strokes. Originally the foliage ~ particularly in the foreground ~ would have appeared a richer, warmer green. Over the centuries the fugitive yellow used in the mixture has faded away.

What is fascinating about this painting is Koninck's willingness to accept and make an artistic virtue of one of the most regular and unvaried landscapes of Europe. He merely hints at a rising foreground, leaving viewers to find their feet on some unexplained but higher vantage point. From it we contemplate the limits of human vision, a privilege that the two men in their little ferry-boat can never attain.

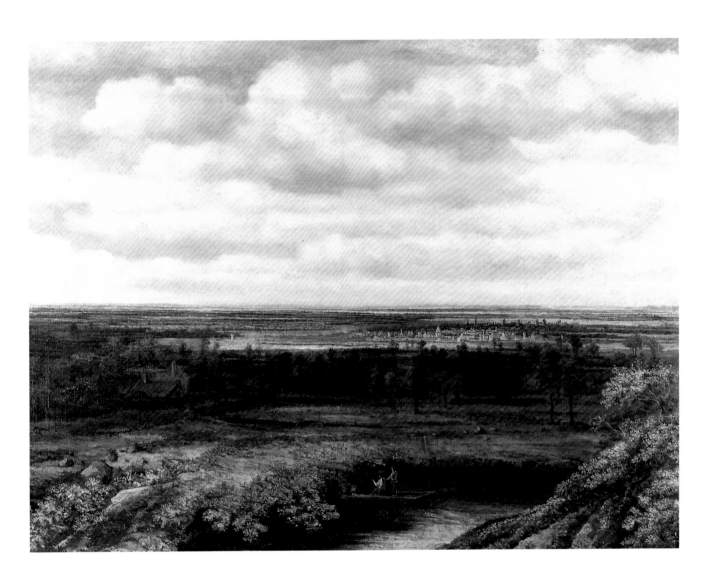

Johannes Leemans

Dutch: c.1633-1688

Still Life with a Gun and Fowling Equipment

Oil on canvas: 114.3 x 156.2 cm.

Presented by Miss Ina J. Smillie, 1963

Very little is known about the life of **Johannes Leemans,** whose equally unrecorded relative, Anthonie Leemans, painted in a very similar style, and is also represented in this collection. Leemans is recorded as working in Utrecht in 1663, Leiden in 1664 and Amsterdam in 1671. From 1673 to 1684 he was in The Hague. He was not an influential artist, but interesting as a highly competent product of the extreme specialisation which Protestant Holland fostered in the development of secular painting in the 17th century. In fact Leemans is known exclusively for *trompe l'oeil* paintings, designed to deceive the eye. The Danish Royal Family were particular patrons, and a number of Leemans' compositions were acquired by the Scottish aristocracy.

Still Life with a Gun and Fowling Equipment, signed and dated 1684, is a Dutch *trompe l'oeil* depicting objects associated with wildfowling. Painted in The Hague, it is typical of the work in which the artist specialised. It is likely to have been produced for a wealthy patron who enjoyed the sport of fowling. The painting may have come to Scotland at an early date as it was owned by an Earl of Hyndford, an Earldom which died out in 1817.

The flintlock gun with Dutch stock of c.1620 is displayed on a wooden rack fastened to the whitewashed wall. The suspended cage contains a small bird, kept as a decoy. Below it hangs a hunting horn, a portable cage, and a bag with pegs and netting, probably for trapping quail. Small birdcalls hang from both racks. To the left are a powder horn, sheathed hunting knives, and two flask-shaped calls, probably for partridge. To the right are a goose-call, smaller hunting horn, and leather bag probably for both powder and shot.

The painting has a very shallow recession into depth (from the feeding bowl on the cage to the wall behind), and the objects are all represented life-size. They are lit with a raking light, with cast shadows skilfully observed. In addition, Leemans has carefully delineated the form, texture and material of each individual object. The perspective indicates a view from below. Properly positioned without a frame, perhaps built in over a door with a window to the left, the painting was designed to trick the eye into believing that the objects were not painted, but real.

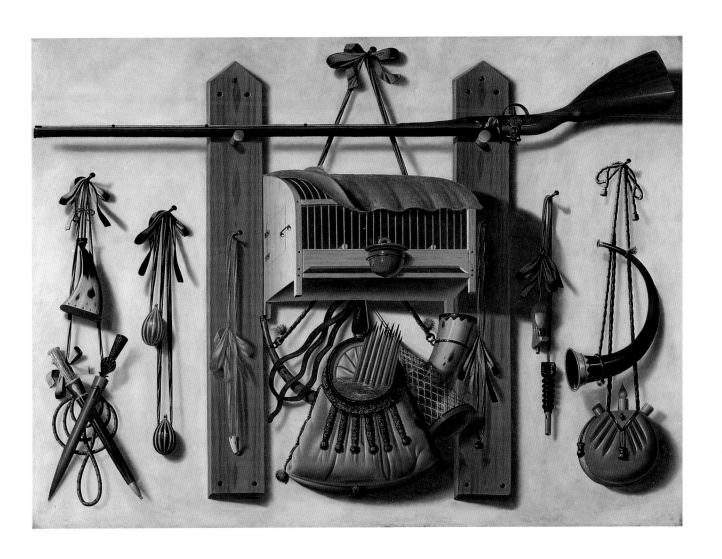

Jean-Siméon Chardin

French: 1699-1779

A Lady taking Tea

Oil on canvas: 80.0 x 101.0 cm.
Bequeathed by Dr William Hunter, 1783

Chardin was born in Paris. He studied there under Nöel-Nicolas Coypel, best known for his history paintings and pastels. Chardin specialised in *genre* painting (scenes of everyday life) and still-life painting of kitchen utensils and the raw material of food preparation. The idea of painting such subjects was first made popular by Dutch artists in the preceding century, and in one form or another has remained popular ever since ~ domestic subjects for domestic walls (though most of Chardin's examples hang now in museums). Chardin had not only the talent to convey the appearance of everyday objects, but also a feeling for composing his pictures to give a grave and monumental character to them. That caused, and still causes, people to reflect on the meaning of simplicity, honesty, order, constancy and transience ~ concepts engendered by his paintings. Chardin became a French Academician at the age of 29, being that body's Treasurer for 20 years. He steadily produced such works throughout his career. They sold well, often to aristocratic patrons, and many were engraved to reach a wider audience. In his last years, with his eyesight failing, he found that pastel drawing enabled him to continue his work ~ a solution which, a century later, his countryman Degas was also to adopt. Chardin died in 1779.

A Lady taking Tea was painted in February 1735, according to an inscription by Chardin found on the reverse during restoration in 1976-7. Its first owner was either the Contesse de Verrue or her son-in-law the Prince de Carignan, indicating the aristocratic esteem in which Chardin's humble subjects were held. Hunter bought it in 1765 for eight pounds from the Carignan sale in London.

As with other works by Chardin, such as the Hunterian's *Cellar Boy* and *Scullery Maid*, it formed a pair with a youth building *A House of Cards* (private collection). This pair has been regarded as presenting variations on the theme of vanity. However, Chardin's ability to understate the subjects of his figure paintings may mean that rather more than the indulgent stirring of a cup of tea ~ a minor pleasure, soon to grow cold ~ is really meant. The figure is probably his wife Marguerite Saintard, who died within two months of the painting's completion. Thus the mood of introspection, and the evanescent steam rising into the surrounding air, may hint at a deeper meaning. If so, dignity and equanimity in face of the transience of life have here been expressed with great sympathy and subtlety. Certainly the painting was not exhibited until 1739, four years after Marguerite's death.

While the painting is of a static subject, reinforced by the subtle verticals of the room panelling, Chardin has contrived a quiet flow of movement to the right. Offset by the chairback, the woman leans forward slightly, and the eddies of the rising steam reflect her inclination. The simple glazed teapot, dark and squat against the atmospheric background, acts as a counterpoint to these movements which are slowed to a halt by the half-open drawer.

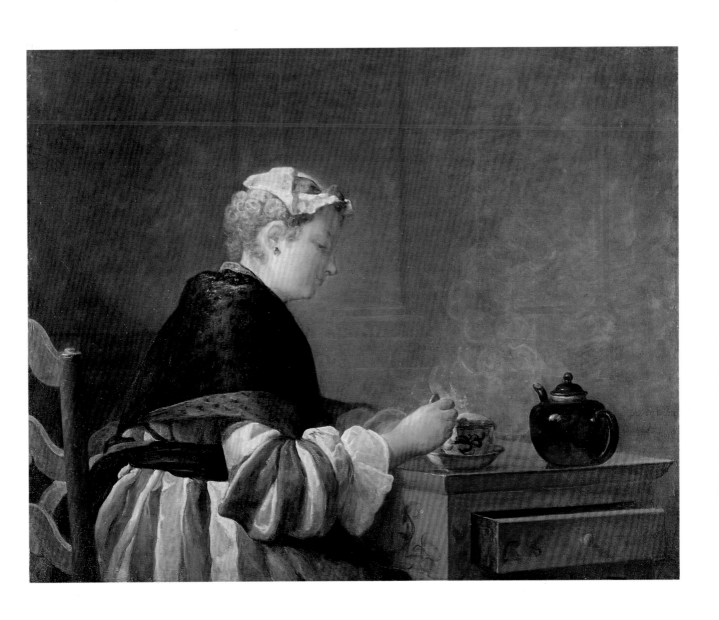

Allan Ramsay

Scottish: 1713-1784

Dr William Hunter: 1718-83

Oil on canvas: 96.0 x 75.0 cm.

Bequeathed by Dr William Hunter, 1783

Ramsay was the son of Allan Ramsay the poet, best remembered for his pastoral, *The Gentle Shepherd*. Ramsay studied in Edinburgh, and subsequently in London with the Swede, Hans Hysing, in the early 1730s, before spending the years 1736-8 in Italy. There he studied under Imperiale at Rome and Solimena at Naples, bringing a cosmopolitan air to British portrait painting on his return. He settled in London, but also maintained a studio in Edinburgh for some years. His sensitive, sympathetic yet highly objective perceptions assure his place among the very best of 18th century portrait painters. His success was immediate, yet he returned to Rome in 1754-7, partly to improve his skill in drawing and composition. In 1761 he was appointed Painter-in-Ordinary to George III, yet declined the knighthood offered in 1769 at the time his younger rival Joshua Reynolds (p. 36) was honoured. The post of Painter-in-Ordinary involved the production of many replicas of his Royal portraits, which he left largely to a well-trained studio. From the mid-1760s he painted little, devoting himself to scholarly pursuits, and ceased painting entirely following an accident in 1773. Both his art and his intellectual interests brought him into close contact with Dr Johnson, David Hume, Horace Walpole, Voltaire and Rousseau. He died at Dover, returning from a further visit to Italy.

Dr William Hunter, pioneer in obstetrics and the teaching of anatomy, was founder of the Hunterian Museum and Art Gallery. Ramsay's portrait of his fellow Scot and contemporary can be dated 1764-5, on stylistic grounds. It is conceivable that the commission was prompted by Hunter's appointment in 1764 as physician to Queen Charlotte; most of Ramsay's sitters in this period had a connection with the Court. The contemporary French frame matches that of Roslin's *Countess of Hertford* nearby, which Hunter also owned.

Described in 1817 by Joseph Adams as "the polite scholar, accomplished gentleman, the complete anatomist and probably the most perfect demonstrator as well as lecturer the world has ever seen", Hunter was a man of energy, fully involved in the world around him. In 1768 he wrote: "I am pretty much acquainted with most of our best artists and live in friendship with them." That was the year he was appointed Professor of Anatomy at the Royal Academy, but his friendship with Ramsay is likely to date back to his Edinburgh student days of the late 1730s.

Probably painted in Ramsay's studio, Hunter is seated and leaning on a table, holding a paper to which he directs our attention, perhaps the above-mentioned letter of appointment. There is very little to distract us from our sense of the sitter's presence. The soft lighting and refined image reflects Ramsay's own interest in contemporary French painting and he may have been influenced by the pastels of Maurice Quentin de la Tour.

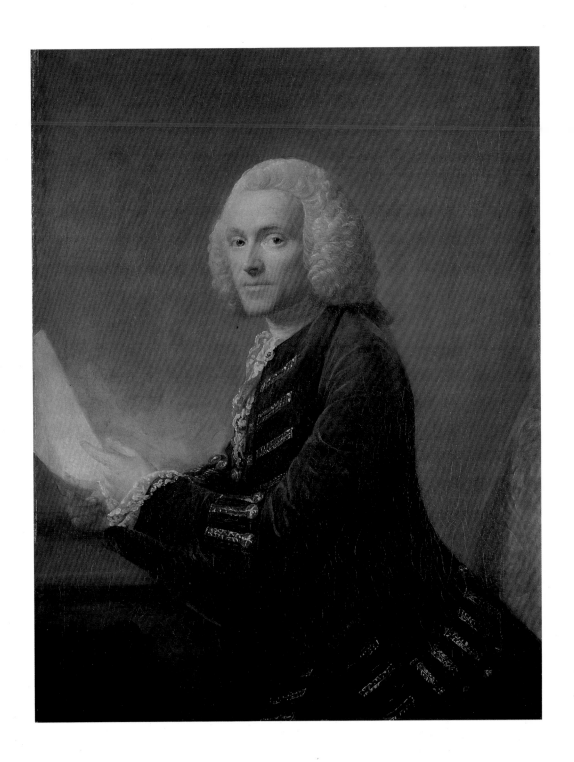

Sir Joshua Reynolds

English: 1723-1792

Nelly O'Brien

Oil on canvas: 125.1 x 100.1 cm.
Presented by the Trustees of W.A. Cargill of Carruth, 1970

Reynolds was born in Plympton, Devon, son of an Oxford graduate schoolmaster. This intellectual and pedagogic background was to prove as significant as his artistic talent in his future career. Apprenticed to Thomas Hudson in London (1740-43) he returned to practise portrait painting in Devon before spending two years in Italy in 1750-52. There he assiduously studied classical sculpture and Renaissance and Baroque painting, with the firm aim of improving his own art by basing his future work on the principles of composition and taste which he found evident in the work of the old masters, and which he styled the 'Grand Manner'. Subsequent to his return to London he became a highly successful portraitist, maintaining a large studio, and painting virtually all of English Society. With others, he promoted the concept of a formal institution to unite and enhance the status of art in Britain and became the first President of the Royal Academy in 1768, being knighted the following year. His versatility in developing new forms for portraiture was matched by his learned *Discourses*; lectures given at the Academy, and aimed at establishing a national school of history painting through rational analytic study of past achievements. These *Discourses* laid a firm foundation for academic study which persisted well into the next century. Reynolds, who counted Dr Johnson, David Garrick and Oliver Goldsmith among his friends, was arguably the single most significant force in the development of British painting in the 18th century.

Nelly O'Brien, a celebrated courtesan in aristocratic circles of the time, sat often to Reynolds, who was a close friend, for a series of charming, private portraits beginning in 1760. This work dates from c.1763-7, the years before her early death in 1768.

She engages the viewer directly with her gentle gaze, and is portrayed seated before a wooded grove, lit by a shaft of afternoon sunlight. In fact, the work would have been painted in the studio. Her restrained jewellery complements the simplicity of her costume. This is conceived with a poetic informality loosely based on classical antiquity, a style of undress popular in pictures of the 1760s and 1770s. According to *The World*, 1763: "it is the fashion for a lady to UNDRESS herself to go abroad, and to DRESS only when she stays at home, and sees no company."

Though seemingly casual, the painting is imbued with the stately and formal artistic considerations which Reynolds had developed in his analysis of the Italian masters of the 16th and 17th centuries. Both the delicacy of modelling in the features, reminiscent of Correggio, and the amplitude of form and drapery which stem from the Venetian tradition, are evidence of Reynolds' desire to experiment with portraiture, and elevate his compositions beyond the mere transcription of an individual's features.

Nelly O'Brien leans on a pedestal upon which the Greek myth of Danaë receiving Jupiter in the form of a shower of gold is depicted as if carved in relief. This is only partially visible now, but can clearly be seen in a contemporary mezzotint print. Danaë was both a symbol of chastity and an example of virgin conception through divine intervention. The association of Nelly (who bore a son of unacknowledged parenthood in 1764) with Danaë may be taken as either a fanciful compliment by whichever of her lovers commissioned the work, or as a rather frank allusion to her rôle in high society ≈ or both.

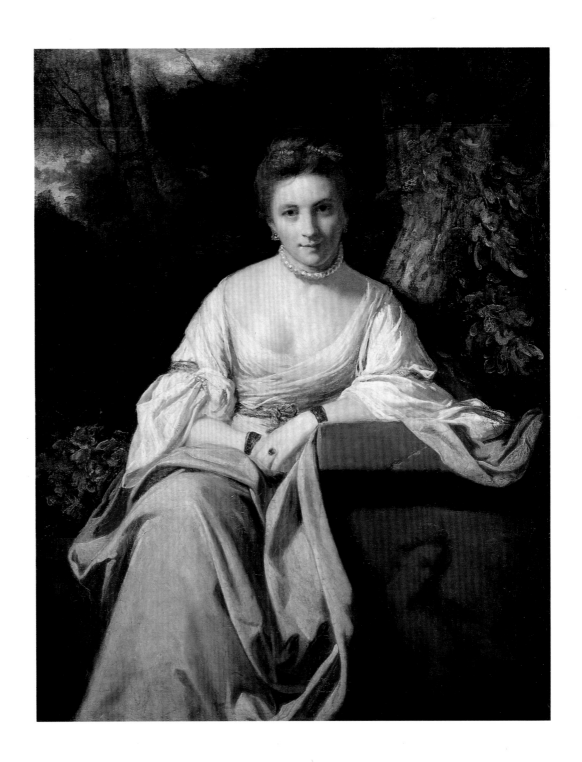

Gavin Hamilton

Scottish: 1723-1798

The Abdication: Mary, Queen of Scots, resigning her Crown

Oil on canvas: 175.3 x 160.4 cm.

Purchased with the aid of a grant from the Government's Local Museums Purchase Fund, 1972

Hamilton, related to an aristocratic Scottish family, was educated at Glasgow University. He subsequently left for Italy, to study painting in Rome with Masucci in the 1740s. Apart from a brief return to Britain from 1752 to 1755 as a portrait painter, his entire career was centred in Rome. There he established himself as an archaeologist (he was one of the team that discovered the 'Warwick Vase' now in Glasgow's Burrell Collection), and an art dealer, as well as being a painter. He combined these interests to create a series of enormous canvasses depicting the history of ancient Greece as related by the poet Homer. His severe and sober style was drawn upon extensively by Jacques-Louis David and his French associates in the creation of the Neo-Classical style of public art. Hamilton's position as an artist is paradoxical. Few have claimed him as a great painter, yet few would deny the strength of his intellect, or the influence of the visual formulations he developed, which were disseminated through engravings commissioned by him, largely from Domenico Cunego. His home in Rome was the most important focus for artists from Britain, and some significant works remain there, in the Villa Borghese.

Mary, Queen of Scots, resigning her Crown was commissioned from Hamilton in 1765 by James Boswell (1740-95), best remembered for his biography of Dr Johnson. On visiting his fellow Scot in Rome, Boswell persuaded Hamilton to recreate one of the most significant events of Scottish history. Boswell sought to brief the artist on every detail, obtaining for him a copy of William Robertson's *History of Scotland*. Exhibited at the Royal Academy in 1786, it helped to establish a tradition of Scottish history painting, and was the first major pictorial manifestation of the cult of Mary, Queen of Scots.

Mary's hasty marriage to Bothwell, implicated in the murder of her first husband Lord Darnley, outraged the Scottish nobles and brought immediate rebellion. At the Battle of Carberry Hill on 15 June 1567, these rebels captured Mary, imprisoning her at Loch Leven Castle. This scene, set in the castle on 24 July, shows Mary being forced by Lord Lindsay to sign abdication papers in favour of her infant son James. Lindsay, in full armour and tartan, is accompanied by a notary. The cloaked spear-bearer is probably William Douglas, owner of the castle and charged with his Queen's detention. Mary, the self-possessed beauty in distress, is supported by a veiled mourner.

Hamilton also sought to convey the ultimate fate of Mary, executed by order of Elizabeth I in 1587, despite assurances apparently guaranteeing her liberty. Contemporary engravings show the full extent of the painting, subsequently cut down. Both the coercive presence of soldiers at the window, and the heavily studded prison door to the right, were originally more emphatic, and more obviously indicative of Mary's fate. The idea of martyrdom is conveyed by analogies with earlier compositions of Christ before Pilate.

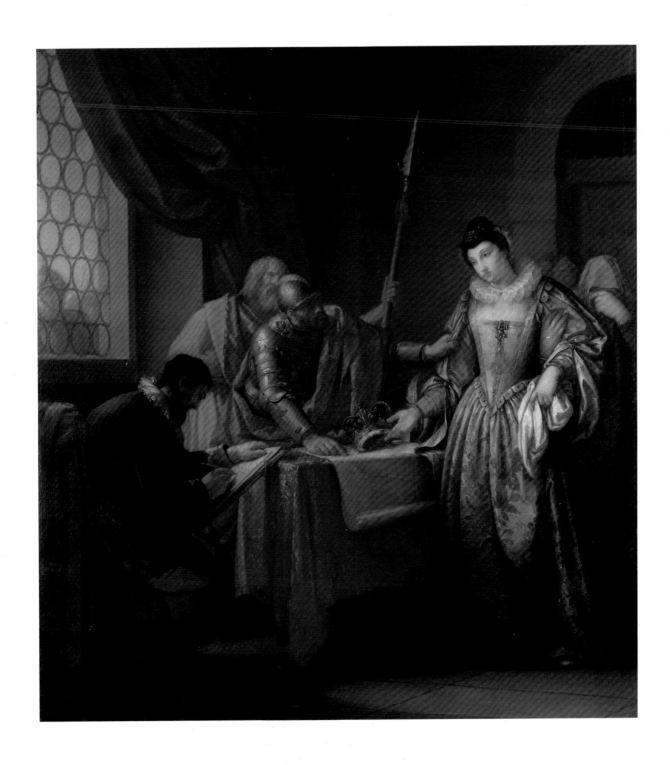

George Stubbs

English: 1724-1806

The Moose

Oil on canvas: 63.2 x 73.0 cm.
Bequeathed by Dr William Hunter, 1783

Stubbs was born in Liverpool, son of a prosperous currier. Apart from youthful contact with the engraver Hamlet Winstanley he had no regular training and was largely a self-taught artist. He subsequently worked as a portrait painter in Leeds, and studied human and animal anatomy at York, where he lectured to medical students. He visited Italy, setting out in 1754, and on his return sequestered himself in a remote Lincolnshire farmhouse, dissecting horses and drawing from them for some 18 months. He established himself in London in 1759, working as an animal painter while also etching the plates for his *Anatomy of the Horse*. This was published in 1766 to great and long-lasting acclaim ~ the finest treatise on the subject both for accuracy and beauty of depiction. It secured Stubbs' position as the pre-eminent horse and animal painter. He produced many portraits of famous beasts with their owners and grooms, and developed a type of conversation piece (a family group portrait) which also involved horses and equipage on an excursion. As well as recording a number of rare exotic animals for the first time he developed highly imaginative groupings ~ such as the *Horse Frightened by a Lion* ~ which anticipated the romanticism of Delacroix or Ward. His painstaking technique was adapted through the encouragement of Josiah Wedgwood to the painting of brilliant fired enamel plaques from c.1770. From 1795 until his death he devoted substantial time to drawings for an unfinished publication on the comparative anatomy of Man, Tiger and Fowl, subsequently lost to sight until 1957.

The Moose, inscribed and dated 1770, has recently been identified as representing *The Duke of Richmond's first Bull Moose* by Dr Ian Rolfe, to whom we are indebted for all that follows. The animal was sent from Quebec in September 1770 as a present to the Duke from the Governor-General of Canada.

The painting was commissioned by William Hunter and while Stubbs has additionally provided a setting evocative of the Canadian wilderness, the work was made for scientific reasons. Hunter went to observe the animal, and obtained "leave to have a picture made of it by Mr Stubbs, in the execution of which, no pains were spared by that great Artist to exhibit an exact resemblance both of the young animal itself, and of a pair of horns of the full-grown animal, which the General had likewise brought from America and presented to the Duke."

Hunter's interest in the Moose derived from his interest in a much broader issue ~ the probability that certain animals had become extinct, as he had proved in his investigation of the Mastodon. Hunter suspected that the 'Irish Elk', known only by excavations of its huge fossilised antlers, was also an extinct animal. Feeling that the spread and weight of these antlers could not be supported by the size and anatomy of the European Elk or the newly discovered Moose, he sought to record accurately all information that came his way. For want of conclusive evidence, Hunter refrained from publishing his investigation. However, the many complete skeletons of the 'Irish Elk' subsequently discovered confirm the accurate direction of his thoughts.

In the origination of this painting were thus combined the skills of a great animal painter and the needs of a natural historian working at the frontiers of knowledge.

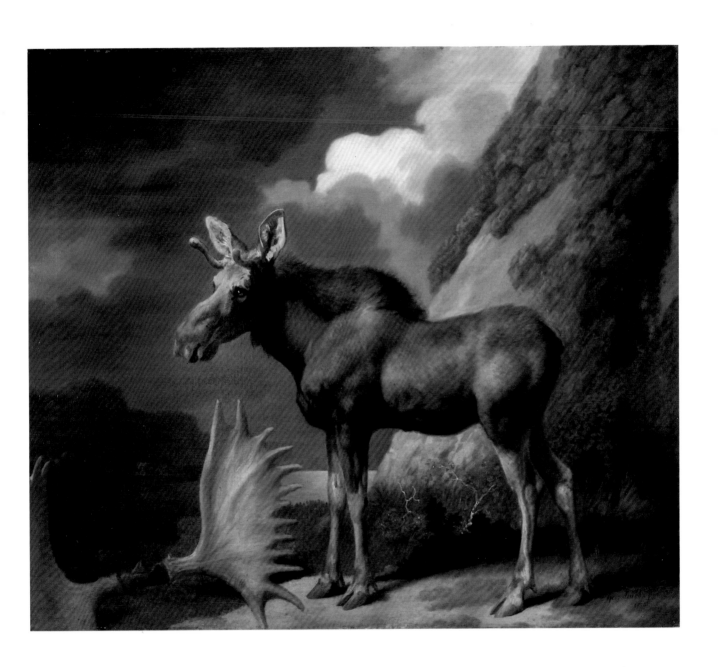

Jean-Baptiste-Camille Corot

French: 1796-1875

Distant View of Corbeil from behind the trees – Morning

Oil on canvas: 46.1 x 55.4 cm.
Presented by the Trustees of W.A. Cargill of Carruth, 1970

Corot was born in Paris. He abandoned a career in commerce to become an artist at the relatively late age of 26. Supported by a family annuity, he studied landscape painting under his exact contemporary Michallon and on his untimely death in 1822 continued under Bertin. For many years Corot travelled extensively in France and Italy drawing and painting directly from nature. On the one hand he wished to record direct observations of the views he selected, while on the other he sought to emulate, in a new way, the great tradition of formally composed classical landscape first developed by his countrymen Claude, Poussin and Dughet in the 17th century. Though he exhibited regularly in the Paris *Salon*, it was not until the Universal Exhibition of 1855 ~ by which time he was nearly 60 ~ that he began to enjoy wide recognition and success. He rapidly became one of the most popular landscape painters of the last century. This late fame and fortune did not affect Corot's personal life, which was characterised by simplicity and generosity to others. His most popular style was not difficult to imitate and forgeries proliferated. Despite criticism of the 'formula' of his later *Salon* landscapes, Corot maintained his creative talent to the end, developing a distinctive achievement as a portrait and figure painter in later life.

Distant View of Corbeil is one of a series of views of Corbeil painted about 1870. The town lies at the confluence of the rivers Essonne and Seine, 18 miles south of Paris. It was exhibited in the *Ecole des Beaux-Arts* Paris in 1875 when it belonged to Docteur Cambay, a leading patron and one of the doctors who attended at Corot's deathbed.

The landscape is composed as a *contre-jour* (against the daylight). The dark foreground has been deliberately created to enhance, by contrast, the brightness of the sky and its reflection in the river, evoking both the coming heat of day and the welcome shade. The long receding diagonal of the river bank runs almost to the left edge of the painting, where the distant church and the arches of the bridge serve as a counterpoint.

Corot's style in later years was a personal amalgam of several aspects of landscape painting. His ability to observe and record accurately the effects of light on landscape was combined with a development of loose and broken touches of paint which are suggestive rather than literal representations. At the same time, he made reference to the poetic classical landscapes of his 17th century countryman Claude Lorrain. Here Corot combines the poetic ideal of landscape with direct observations of his local countryside. Two peasant women substitute for the nymphs and shepherds of the classical landscape, and the town of Corbeil for the distant temples of Arcadia. In addition, the deliberate soft focus of the foreground against the sharp relief of the distance parallels aspects of early photography. All these issues are united to instil a profound feeling of ease and tranquillity in the viewer.

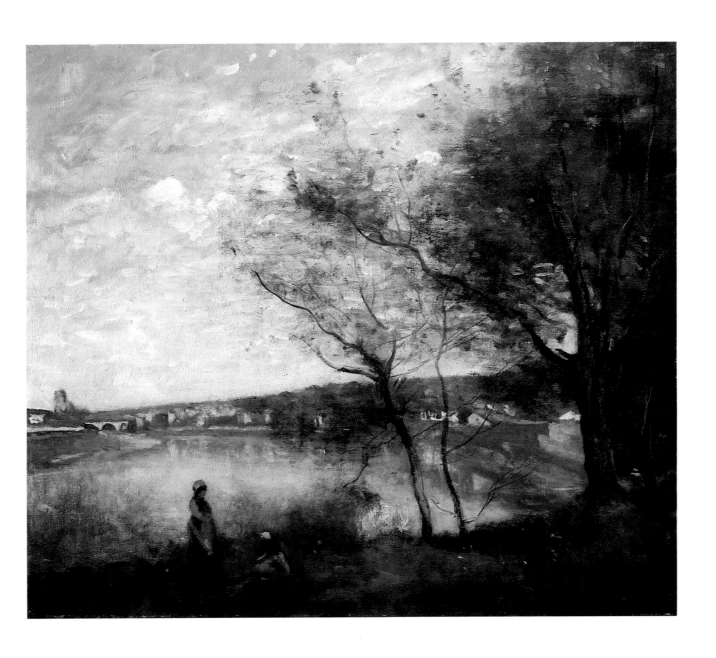

Camille Pissarro
French: 1830-1903

A Misty Morning, Rouen
Oil on canvas: 57.1 x 73.5 cm.
Presented by the Trustees of W.A. Cargill of Carruth, 1970

Pissarro, born on the island of St Thomas in the West Indies, arrived in Paris in 1855, where he studied at the *Ecole des Beaux-Arts* and subsequently the *Académie Suisse*, meeting Corot and Monet in the process. He exhibited at the *Salon des Refusés* in 1863. His house at Louveciennes was overrun and his paintings destroyed during the Prussian invasion of 1870-71, and he joined Monet in London, studying Turner and Constable, and painting in the suburb of Norwood. A staunch member of the Impressionist group, he was the only one to exhibit in all eight of the Impressionist exhibitions (1874-86). In the mid 1880s he experimented with Pointillism, a scientific analysis of the Impressionist technique developed by Seurat, but subsequently abandoned this disciplined approach for a freer style. Pissarro's gifts as a painter were allied to a congenial personality. His Anarchist philosophy of individual responsibility for the progress of all led him to offer encouragement to younger talents ~ Gauguin and Cézanne among them ~ and to act as peacemaker among his Impressionist associates. His eldest son Lucien (1863-1944), the most notable of his artistic progeny, settled in England in 1890, encouraging understanding of modern French art, and producing fine illustrated books at his Eragny Press.

A Misty Morning, Rouen is signed and dated 1896. Having produced some 13 canvasses from his first visit to Rouen in 1883, Pissarro returned in 1896, both in the early months and in the autumn, and finally in 1898. It is thought that this painting comes from the second of his 1896 visits. He stayed then at the Hotel d'Angleterre, overlooking the Seine. The Quai de la Bourse forms the foreground and across the river, downstream, is the Quai de la Salle and the warehouses of the southern quarter of St Sever.

Pissarro was extending his interest in landscape painting to grapple with the dynamics of an expanding industrial city. Like his Impressionist colleagues Monet and Sisley (p. 52), the same motif was often painted from similar viewpoints, but under the transforming effects of weather and light. Pissarro's own description of his progress that year encapsulates his intent: "I've got effects of fog and mist, rain, sunset, overcast skies, motifs of the bridges cropped in different ways, quays with ships...vehicles, pedestrians, workers on the docks, boats, steam, mist in the distance, very vivid and active."

That description, largely of another painting, ends with the telling sentence: "I am waiting for a nice shower to put it all in order." It would be wrong to assume that Impressionist paintings were literal records of given moments. There are elements of *Misty Morning* which clearly indicate studied composition ~ for example the jibs of the two steam-cranes which 'point' to the rising smoke activating the sky over the far bank. The canvas is an arena for recording incidents as they occur, sifted and edited to completion. The richness of surface, the delightful detail, both in the movement of figures and the surprising touches of local colour, indicate a prolonged period of observation and application to create the appearance of a brief moment in time.

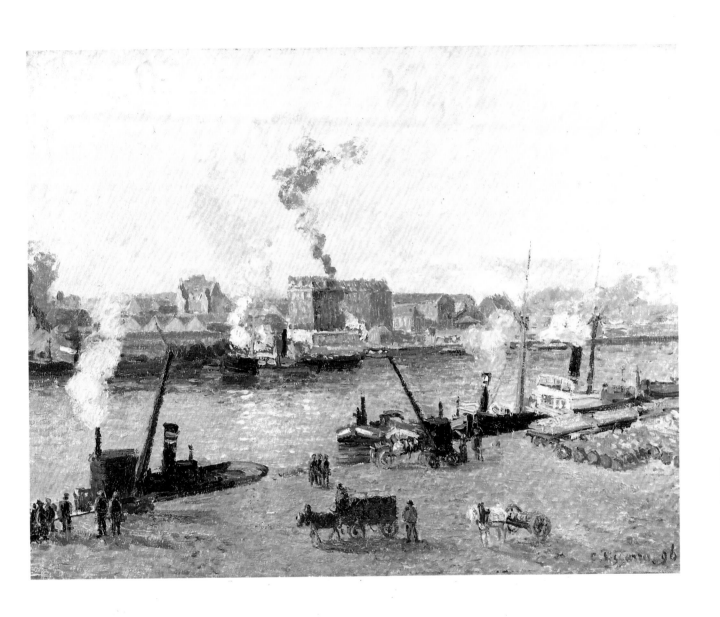

James Abbot McNeill Whistler

American: 1834-1903

Harmony in Red: Lamplight

Oil on canvas: 193.4 x 90.8 cm.

Bequeathed by Miss Rosalind Birnie Philip, 1958

Whistler was born in Lowell, Massachusetts, and as a boy was in Russia with his railway engineer father. Returning to America he entered West Point Military Academy in 1851. Neither a military career, nor a brief spell as a cartographer, suited him, and he left to study art in Paris from 1855 to 1859. Studying under Gleyre he became friends with Legros, Fantin-Latour (p. 50), and Courbet. His reputation as a printmaker began early, with the *French Set* (1858), followed by brilliant etchings of London's dockland, over the next few years, finally published as the *Thames Set* in 1871. He had settled in London in 1859 but returned to France regularly, meeting Manet and exhibiting *The White Girl* at the *Salon des Refusés* in 1863. During the 1860s and 1870s Whistler assimilated French, oriental and classical sources to create his *Harmonies*, *Symphonies* and *Nocturnes*, paintings which emphasised the formal and aesthetic nature of his work in opposition to Victorian obsessions with detail and subject. Bankrupted by his successful libel suit against the critic Ruskin in 1878, he removed to Venice, regaining his reputation with the etchings and pastels he made there, and on his return to London sought success as a portrait painter. This success was limited, as his search for perfection led to interminable sittings. A cosmopolitan wit and dandy, Whistler was as famous for his lifestyle as for his art, the meaning of which he articulated best in his *Ten O'Clock* lecture, 1885. The later part of his career saw him variously resident in London or Paris, with visits to Belgium and Holland, to Ireland, Algeria and Corsica. Gwen John, Menpes and Sickert are among the most notable of a considerable number of younger artists who were influenced by Whistler's art.

Harmony in Red: Lamplight, bearing Whistler's butterfly monogram, is a portrait of Beatrice Birnie Philip (1857-96), who married Whistler's friend the architect E.W. Godwin in 1876. It was probably begun in 1884, but there were many sittings, lasting until late in 1886, before exhibition at the Society of British Artists that winter. Though finished, and admired, the painting was never sold. Godwin died in October 1886, and Whistler married Beatrice in 1888. For Whistler the painting would convey many memories ~ of Godwin's friendship, of love, and of sorrow, for Beatrice died of cancer in 1896. Following from it, an extensive series of similar works evolved, of his sisters-in-law Ethel and Rosalind, most of which are also in the Hunterian's collection.

When exhibited, the striking pose was both appreciated as free and frank, and criticised as unladylike. The critic Malcolm Salaman regarded it as one of Whistler's finest works: "...her attitude is singularly vivacious. The colour is simply wonderful, and is another proof of Mr Whistler's pre-eminence as a colourist...".

The work was painted under specially designed gas lamps, providing a warm yellow light which gave an extra intensity to the reds during sittings. Whistler's experiment with painting in this artificial light may have been for two reasons. Firstly, he could guarantee identical conditions for sittings at any time. Indeed he called for Beatrice, on discovering a cancellation by a society sitter: "Do...come over to the studio at once....We can darken the place and turn the gas". Secondly, Whistler may have thought that works painted under these conditions would retain their effect in public, given the growing use of gas lighting for exhibitions. However, he seems to have lost interest after attempting one further painting under gaslight.

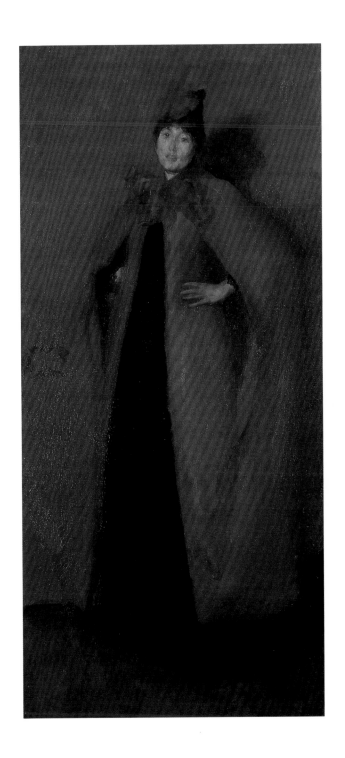

William McTaggart
Scottish: 1835-1910

The Fisher's Landing
Oil on canvas: 98.0 x 134.5 cm.
Presented by Mrs G.B. Dunlop, 1951

McTaggart was born in Aros in Kintyre, a son of Gaelic-speaking crofters. Apprenticed locally to the Campbeltown apothecary, his artistic abilities were encouraged by Sir Daniel MacNee, and he enrolled at the Trustees Academy, Edinburgh, under Robert Scott Lauder at the age of 16. He began exhibiting in 1855 and, while his early poverty ensured a willingness to tackle any commission, he soon established a preference, and reputation, for scenes of everyday life in seaside and rural settings. These were partly inspired by the example of Millais and the Pre-Raphaelite group. He became an Associate of the Royal Scottish Academy as early as 1859 (R.S.A. 1870). McTaggart rarely left Scotland, and developed independently a broad and sparkling technique which paralleled in some respects the approach of the French Impressionists. While most works were painted in the studio, he certainly commenced many ~ including canvasses of very large dimensions ~ in the open air. McTaggart's art was popular, and this popularity has never waned. Nevertheless his achievements are little known outside Scotland. While in later years he established a studio at Broomieknowe, south of Edinburgh, he constantly returned for extended periods of work both to the rugged coastline of Kintyre, and to the east coast of Fife, where he enjoyed considerable support from Dundee collectors led by James G. Orchar.

The Fisher's Landing, signed and dated 1877, was begun at Carnoustie on the Angus coast in September 1875. Its first owner, the Glasgow collector A.B. Stewart, wrote in appreciation: "It lightens and brightens up all the room and would indeed 'make sunshine in a dark place!'."

This effect was characteristic of McTaggart's mature work. When shown at the R.S.A. in 1878, the work bore a sub-text: "The air and the water dance, glitter and play". There is however another sub-text to *The Fisher's Landing*, and other paintings of fisher folk by McTaggart. Fishing was an important part of the economy, particularly fishing for the herring, that most preservable of fish before the age of canning and freezing. Most fishing was from small sailboats, at the mercy of wind and tide. While not an overt social realist, McTaggart knew well that such idyllic scenes could soon be replaced by disasters like *The Storm* (1890, National Galleries of Scotland), and that the little scattered communities that harvested the sea were often brought to despair and near starvation by the loss of menfolk and boats alike.

McTaggart's direct observations of nature were developed in his studio. The central figure, bearing both fish and baby, was the subject of preparatory drawings traced onto the canvas. The eye is led from the foreground girl, waiting with her emptied basket, to the figures advancing with their loads of fish. The landing place is concealed below rocks to the left, with the next arrival, sail being furled, a few yards offshore. In line astern across to the right horizon advance the last three boats. McTaggart succeeds in unifying this painting in two particular ways. Bold and rhythmic brushwork interprets the shimmer of light bathing both sea and shore, while the interrelated activities of the fisherfolk animate the entire surface and depth of the composition.

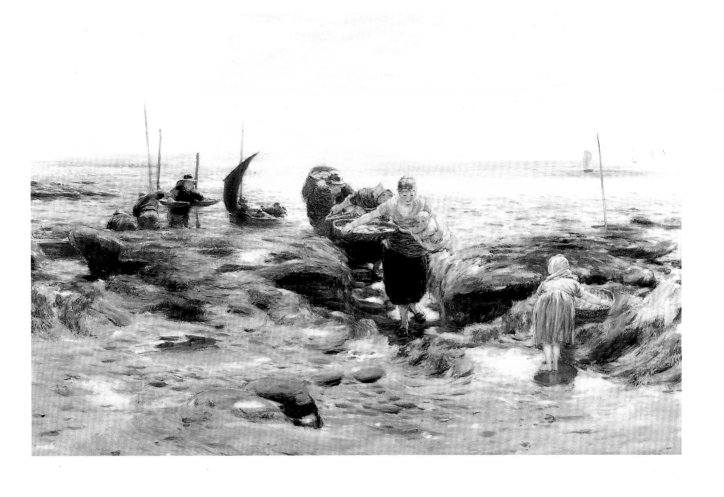

Ignace-Henri-Théodore Fantin-Latour

French: 1836-1904

Roses and Larkspur

Oil on canvas: 59.7 x 49.4 cm.
Presented by Mrs G.B. Dunlop, 1951

Fantin-Latour was born in Grenoble. He was taught first by his father, a landscape painter of Italian descent, and later by Lecoq de Boisbaudran in Paris. He also attended the *Ecole des Beaux-Arts* and the studio of Gleyre, where he met Legros and Whistler (p. 46). For several years these three formed a close-knit group exchanging ideas on art, and encouraging each other's progress. Fantin-Latour made several visits to London, where Whistler had settled, and was friends with the etcher Edwin Edwards, whose wife acted as Fantin's English dealer. Fantin-Latour was closely associated with the progressive interests in French art and criticism, being on personal terms with Manet, Degas, Bracquemond and Baudelaire, but his own artistic development was more conservative, owing a considerable debt to the art of Corot (p. 42). He painted some fine group portraits of his associates, and later created paintings and lithographs inspired by the music of Wagner and other operatic composers. He was also a painter of still-life, particularly flower subjects. He is best remembered for these latter works, and rightly so, for he produced some of the most sensitive and gratifying renditions ever seen on the simple theme of flowers in a vase of water.

Roses and Larkspur, signed and dated bottom left, was painted in 1885, and sent to be exhibited in London at the Royal Academy in 1886. It was initially owned by Fantin's English friend and patron, Mrs Elizabeth Edwards, wife of the etcher Edwin Edwards. By 1936 the painting had been cut in two, with the Roses and the Larkspur framed separately ~ a rather sad reflection on the commercial demand for Fantin's works. Subsequently the two halves were skilfully reunited and the join, though visible, is not obtrusive. Though this work does not approach the very best of Fantin's flower pieces, the ill-treatment it suffered must be a contributory factor.

The composition is a simple one, the plants set against a background created by scrubbing over the white ground of the canvas with the thinnest of brown pigments. This plain but atmospheric background may derive from Fantin's appreciation of the still-lives of his compatriot, Chardin, a century before. The light and feathery stems of larkspur soar upwards, contrasting with the more solid weight of the roses. All is arranged so that only enough of the vases containing them is indicated to give understanding of the presentation, without competing with the blooms themselves. The supporting table is likewise given the barest indication, enough only to hint at spatial relationships and gravitational support. These devices aim to concentrate our attention fully on the flowers and foliage, and on the fall of a gentle light, which, modifying the colours and moulding three-dimensional form, provides the unifying strength of the painting.

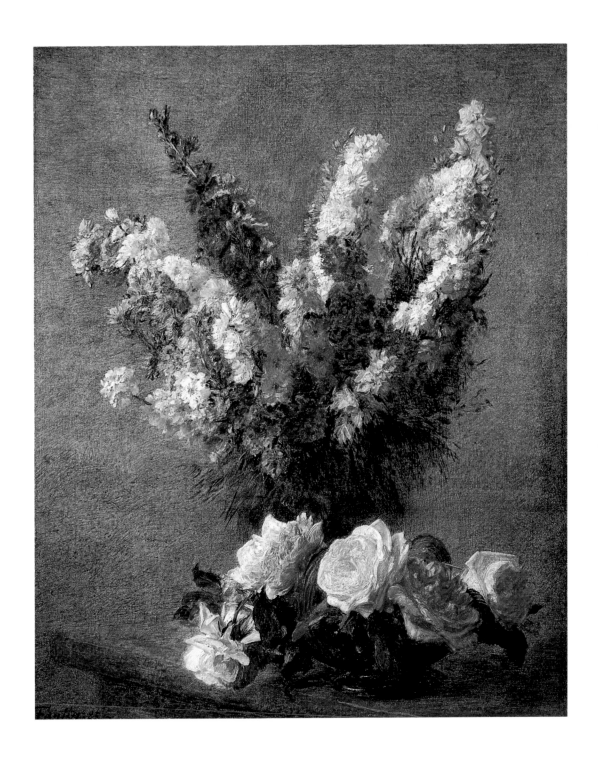

Alfred Sisley

English: 1839-1899

The Church at Moret-sur-Loing

Oil on canvas: 65.9 x 81.3 cm.

Allocated by H.M. Treasury in lieu of Capital Transfer Tax, 1980

Sisley, born of Anglo-French parents in Paris, spent virtually all of his career in France. Sent to England to begin a commercial career (1857-61), he abandoned this to study painting in Paris under Gleyre (1862-3) where he met Monet, Renoir and Bazille. With them, he painted in the Forest of Fontainebleau and at other locations in the next few years. The earlier influence of Corot and Courbet was gradually replaced by the application of principles that led to the development of Impressionism. The Franco-Prussian war of 1870-71 ruined his father's business of making artificial flowers, leaving Sisley with the sale of his paintings as his only means of support. He lived then at Louveciennes, where Renoir was a near neighbour. Sisley visited England in 1874, painting at Hampton Court and in the London suburbs. That same year he contributed to the first Impressionist exhibition. Sisley's sensitivity as a landscapist, his delicacy of touch and sureness of composition mark him as a significant contributor to the Impressionist movement. Years of financial hardship and negative critical opinion followed him through the various countryside locations in which he worked. He settled finally at Moret in 1882, and only in the last decade of his life did he obtain sufficient recognition to live in reasonable security. He made a last visit to England and South Wales in 1897. While clearly a French artist, his attempts to obtain French citizenship in later life met with bureaucratic difficulties and he died a British national.

The Church at Moret is signed, and dated 1893. A clue to Sisley's intentions is given on the reverse, where he has inscribed it: "L'église de Moret (temps de pluie)/ (Decembre 1893) matin". It formed part of a series, painted under precise atmospheric conditions; in this case on a rainy winter morning, or more likely over a number of wet mornings, in December 1893.

Sisley eventually painted 14 views of this church from the second floor window of a nearby house, over the years 1893-4, depicting it at different times of day throughout the seasons and under varying weather conditions. He varied these compositions by using vertical or horizontal formats for his canvasses, and by shifting his viewpoint, or his 'depth of field' in subtle ways. Sisley intended that the entire series should be exhibited together, though this was never achieved.

This obsession with a single 'motif' ~ an apparently stable and obvious object in the real world which yet changes constantly depending on how and when it is viewed ~ is typical of the later development of Impressionism. Claude Monet is the exemplar of this approach, and his series on Rouen Cathedral was an immediate precedent for Sisley. Pissarro (p. 44) also experimented with it.

That potentially infinite variations on appearance could be a fit subject for painting is perhaps best understood in relation to scientific advances in the 19th century, which were based on precise and measurable observations, and the invention and deployment of methods and tools to achieve accurate analysis. Sisley and his Impressionist colleagues were not scientists as such, yet they seem to have been as equally concerned to both question and extend general perceptions, through rigorous and controlled observations of the appearance of things.

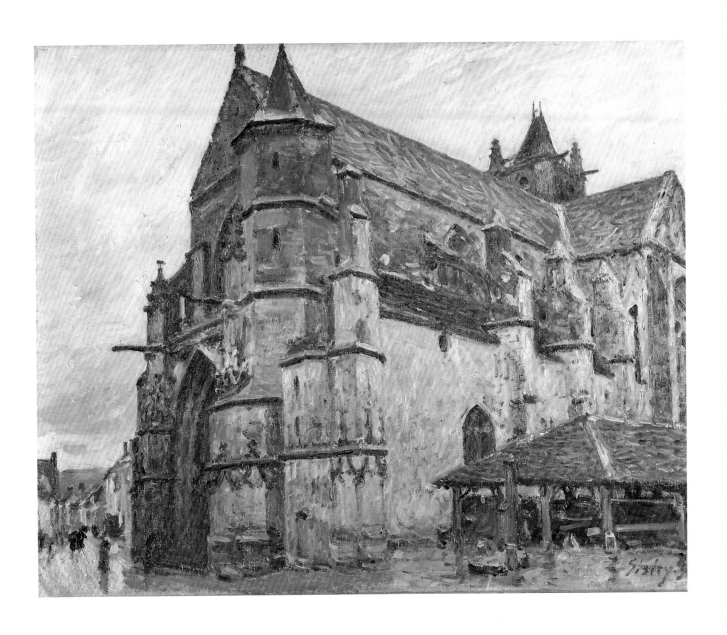

Auguste Rodin

French: 1840-1917

Saint George

Bronze: 60.0 x 52.0 x 29.5 cm.
Presented by the artist, 1906

Rodin was born in Paris and studied under Lecoq de Boisbaudran (1854-7). He failed to gain entrance to the *Ecole des Beaux-Arts*, and while he attended classes of the sculptor Barye, his training was fragmentary and he spent many years as a mason and assistant to other sculptors. He visited Italy in 1875, and felt himself liberated from academic practice through study of Michelangelo. *The Age of Bronze*, exhibited on his return, caused a furore but at least established public recognition. A state commission for bronze doors to an intended museum of decorative arts was awarded in 1880. Rodin conceived *The Gates of Hell*, but this large and complex project remained unfinished at his death. However, many of the individual figures and groups designed for it ~ for example *The Thinker* and *The Kiss* ~ were developed by Rodin as independent works. Rodin was unlucky with public commissions, for the expressive immediacy of his figures, and the almost brutally rugged nature of his modelling often resulted in the rejection of the finished work, or requests for alterations. Despite this, Rodin achieved international status in later life. The history of sculpture is littered with broken fragments, and Rodin explored the power of the fragment, deliberately creating 'incomplete' works, particularly in attempts to capture movement or to express pathos. While the symbolic and literary associations of his work seemed outmoded early this century, he exerted a profound influence on the development of sculpture, numbering Bourdelle and Maillol among his assistants. The *Musée Rodin* in Paris is formed of the contents of his studio, bequeathed to the Nation on his death.

Saint George, cast in 1906, is one of a number of versions of a free-standing bust, *La France*, of 1904, to which the artist gave various different titles, *Byzantine Empress, Empress of the Late Empire, Empress of the Lower Nile* and *Bust of a Young Warrior*. It was presented to the University by the artist in gratitude for the honorary degree conferred on him in April 1906. He probably intended the new title as a compliment to the University, not realising that England and Scotland did not share the same patron saint. Another cast, presented by Rodin to the Victoria and Albert Museum in 1914, was patriotically renamed *La France*. The bust is inscribed *A. Rodin*, in addition to a dedicatory plaque fixed to the background. The design of the frame is unlikely to have been Rodin's and was probably conceived by the University's Master of Works in 1911.

The model was Camille Claudel (1856-1945), sister of the poet Paul Claudel. Rodin met her in 1882 among his group of women students, and she became his 'grande passion'; inspiration of his work, pupil, model, assistant and mistress. Their relationship lasted until about 1889, when her mental state was already disturbed; from 1913 until her death she was confined in an asylum.

To his earlier portrait study Rodin added shoulders and a helmet, to heroic effect, in 1904. He may have privately thought to associate Camille with Minerva/Athene, Goddess of the Arts. This version is richly patinated and polished. The sculptor sought to create life and movement within the sculpture through exploiting the differing reflections of light, both from the relatively smooth surface of the skin, and from the intricate textural interplay of clothing, hair and helmet.

Edwin Atkinson Hornel

Scottish: 1864-1933

The Brook

Oil on canvas: 41.1 x 51.3 cm.
Presented by Emeritus Professor A.L. Macfie, 1979

Hornel was born in Bacchus, Australia, to where his parents had emigrated from Kirkcudbright in Scotland. They returned to Kirkcudbright the following year, and it remained Hornel's base for the rest of his life. After study at the Trustees Academy, Edinburgh (1880-82), he moved to Belgium, attending the Antwerp academy under Charles Verlat from 1883 to 1885. Further continental influences were absorbed both directly, through the work of Monticelli exhibited in Glasgow, and through the interpretations of such Glasgow painters ~ The Boys ~ as Guthrie, Walton and Henry. Hornel and Henry became close friends, collaborating on joint paintings and spending most of the years 1893-4 painting together in Japan and absorbing some of the precepts of Japanese art and design. Hornel subsequently applied these precepts both to his art and to the Japanese-style garden (probably then unique in Scotland) which he laid out at his home. He sought further oriental stimulus on visits to Ceylon (1907) and Burma and Japan (1922), but the work of his maturity, while immensely popular then and since, was repetitive, and lacked imagination. His presence helped to create a vigorous artistic colony in Kirkcudbright, which included Charles Oppenheimer, Jessie King and E.A. Taylor. Subsequent to his death in 1933, Broughton House ~ his home, studio and garden ~ has become a public museum.

The Brook, signed and dated 1891, was exhibited at the Glasgow Institute of that year, and purchased for £30 by Herbert MacNair, a close friend of C.R. Mackintosh. Described in a review as a "curious piece of fantasy...bizarre, mannered and uncommon to a degree", Hornel had clearly moved away from the earlier naturalism of the Glasgow Boys to whom he is allied.

While the painting draws on the landscape of the Galloway area, it is a studio invention. A brook meanders through the picture like a broad blue ribbon. The colour is permeated with autumnal tints, yet the light which bathes the scene has no clear direction. Although painted two years before his visit to Japan (1893-4), Hornel's interest in Oriental motifs is apparent in the decorated smock of the principal figure. At a glance, pattern and colour, allied to a richly varied paint texture, appear to be Hornel's main considerations. But the work goes beyond decoration, and has a symbolic content to which contemporary critics alluded, but did not define.

The foreground girl, rather suggestively drawing a fruit to her open mouth, under a darkening sky, is redolent of images of Eve at the Tree of Knowledge. This impression is reinforced by the serpentine writhings of the tree-trunk, the outline of her skirt, and the brook itself, which separates her from the other girls. Of these, one observes her with frank attention, and will surely cross the brook herself one day. The other turns her gaze away, towards the most distant figure, who, bathed in light, sits Buddha-like in contemplative profile. The theme is that of innocence and experience, of the awakening conscience, and of the spiritual and carnal duality of life.

Seen as such, *The Brook* is an important link between the robust naturalism of the Glasgow Boys, and the development of the clearly delineated ~ if equally obscurantist ~ symbolism of the young C.R. Mackintosh and his circle.

John Quinton Pringle

Scottish: 1864-1925

Children at Play

Oil on canvas: 76.2 x 63.6 cm.

Presented by Professor A.L. Macfie, 1973

Pringle, one of eight children of the stationmaster at Langbank, was apprenticed at the age of 12 to an optician in London Road, Glasgow. From 1883 to 1895 he attended evening classes in art run by the Glasgow School Board and subsequently at Glasgow School of Art. While winning medals and scholarships offered nationally by the South Kensington School, he continued his apprenticeship, setting up his own business as an optician at 90 Saltmarket in Glasgow around 1896. He exhibited paintings, watercolours and miniatures regularly at the Glasgow Institute, was closely associated with the Glasgow Boys circle, and had work included in the *XV* Secessionist Exhibition, Vienna, in 1902. Despite the admiration for his work, Pringle never gave up his business as an optician to become a professional artist, and travel was confined to brief holiday painting excursions in Scotland and England, and a visit to Caudebec, Normandy, in 1910. He retired from business in 1923, but died before he had much opportunity to paint full-time. The residue of his artistic estate, with further contributions from James Meldrum, son of a student colleague William Meldrum, is held by Glasgow Art Gallery and Museum.

Children at Play is signed and dated 1905. From his retrospective show at Glasgow School of Art in 1922, Pringle sold it for £50 to William Davidson, who had earlier commissioned miniatures from Pringle, and who was Mackintosh's patron too. Davidson hung it in the hall of 78 Southpark Avenue (now reconstructed as *The Mackintosh House*).

Pringle produced several works featuring children in a landscape setting between c.1895 and 1905. This one is distinguished by its larger size, and the large scale of the figures to the setting. In part it relates to the work of E.A. Hornel, (p. 56) and in part to the decorative Glasgow Style. Pringle also developed the use of the square brush-stroke, taken over by the Glasgow Boys from the Frenchman Bastien-Lepage. He also seems to have had knowledge of the Neo-Impressionists, who painted with minute dots of complementary colours that mixed optically at a distance. This was possibly through the works of Le Sidaner, who sent works to the Glasgow Institute in the years 1903-6.

However, *Children at Play* is not an amalgam of other artists' work, for Pringle had a distinctively individual vision and sense of colour. He has been particularly concerned to present a flat, decorative quality by the use of firm precise outlines. The delicately graded landscape recedes 'up' the picture plane as much as it recedes 'into' the distance. While a very accurate draughtsman, Pringle has distorted the figures to accentuate their adolescent qualities. The skipping girl is almost entirely two-dimensional and the arrangements of her arms and the rope are contrived to create surface pattern. These decorative qualities are combined with some very precise observations. In particular the intent expression and pursed lips of the skipper are a wonderfully acute study of childish concentration.

Charles Rennie Mackintosh

Scottish: 1868-1928

Desk and Chair 1900

Painted oak: Desk, 128.0 x 173.0 x 51.6 cm.; Chair, 151.9 x 48.0 x 46.0 cm.

Presented by Hamish and Cameron Davidson, 1946

Mackintosh was born in Dennistoun, Glasgow, son of a police Superintendent. In 1884 he was apprenticed to the architect John Hutchison, and commenced evening classes at Glasgow School of Art. He entered the practice of John Honeyman & Keppie as a draughtsman in 1889. Under the guidance of Fra Newbery, Director of the School of Art, he and fellow architect Herbert MacNair formed a creative alliance with the sisters Margaret and Frances Macdonald which was central for the development of the 'Glasgow Style' of decorative art and design. 'The Four' obtained critical success around the turn of the century, participating in the 1900 Vienna Secession and the 1902 Turin International, among other European exhibitions. In 1896, while still officially a draughtsman, Mackintosh won, and designed throughout, a major commission for Glasgow's new School of Art. This was built in two stages, and completed in 1909. Other notable buildings included Queen's Cross Church (1897-9), Windyhill (1899-1900), The Hill House (1902-3) and Scotland Street School (1904-6). He developed a reputation for interior design which ensured employment by Catherine Cranston on her series of Tea Rooms from 1896 to 1914. Mackintosh resigned his practice in 1913, leaving Scotland in 1914 for Walberswick, Suffolk, then London from 1915 to 1923. Failing during the First World War to establish himself as an architect, he relied largely on textile designing as a means of support. Of his architectural projects, only the interiors of 78 Derngate, Northampton (1916-19) were realised. He moved in 1923 to the south of France, painting chiefly landscape watercolours, and supported by a meagre inheritance of his wife's, returning to London for medical treatment in 1927 and dying there the following year.

This **writing desk and chair** form part of the furniture Mackintosh designed for his flat at 120 Mains Street, (now Blythswood Street), Glasgow. Mackintosh would have been planning alterations to Mains Street in late 1899, and this desk is probably first of the several that he designed in his career.

Notes on the drawing for it outline the work expected of the cabinet maker, and the decorative detail that Mackintosh would supply ~ a pair of silvered beaten copper panels ~ almost certainly the work of Margaret Macdonald. The internal arrangements are ingenious; there are ample pigeon holes and shelves, and a sliding desk-top, behind the doors. The gable ends are formed into cupboards, possibly for rolled plans. Built of oak, the drawing indicates that the ellipses formed by the applied beading were to be filled with purple glass or paint. No trace remains, as the desk was stripped and stained dark brown, c.1920, and the current paintwork is a restoration of 1981. Mackintosh was particularly interested in the painting of furniture. By carefully filling the grain, and applying many well rubbed-down coats of paint, Mackintosh sought to transform the nature of his basic materials to emphasise the pure form of his design.

The high-back chair is a painted version (possibly the prototype) of the dark-stained suite created for the Ingram Street Tea Room, Glasgow, a project completed in 1900. Paintwork apart (again this is a restoration of 1981) the only difference is in the small squares of the upright splats, which are fitted with fillets, and may have held coloured glass. Desk and chair were designed independently, though the pronounced vertical thrust of the latter marries well with the broad horizontal emphasis of the former.

John Duncan Fergusson

Scottish: 1874-1961

Woman, Flowers and Fruit

Oil on canvas: 112.0 x 97.4 cm.

Presented by the J.D. Fergusson Art Foundation in memory of Professor Andrew McLaren Young, 1975

Fergusson, born in Leith, abandoned an initial interest in medical training for painting. He spent brief periods at the Royal Scottish Academy School and at the *Académie Colarossi*, Paris, but formal instruction failed to stimulate him. The 'Glasgow Boys', Arthur Melville and Whistler (p. 46) were early influences. He made regular visits to Paris from the mid 1890s and also visited Spain and Morocco. Settling in Paris in 1907, he taught at the *Académie de la Palette*, run by Jacques-Emile Blanche, where he met Dunoyer de Segonzac, who was to be a lifelong friend. Fergusson was extremely receptive to the artists of the *Salon des Indépendants*. The works of Friesz, Camoin, van Dongen, Denis and Bourdelle were of particular significance for him. Under the influence of the latter he began to sculpt in 1908. He was the visual arts editor of *Rhythm*, founded by John Middleton Murry and Michael Sadler in 1911. The title, which he provided, reflected his own interest in contemporary dance and music, an interest enhanced by his meeting in 1913 with Margaret Morris, a pioneer of modern dance, later his wife. At the outbreak of war the couple moved to London and he painted a series of mechanistic pictures of ships and submarines in 1918. After the war he continued to make regular visits to the South of France, but failed to regain the vitality of his pre-war work. On settling in Glasgow in 1939 he became an inspirational figure for younger Scottish artists as a founder member of the New Art Club in 1940, from which emerged 'The New Scottish Group', as author of *Modern Scottish Painting* (1943) and as art editor of *Scottish Art and Letters* (1944).

Woman, Flowers and Fruit, c.1910, is one of an important group of large-scale paintings of nudes on which Fergusson worked in Paris from 1910-12. In this composition can be seen the influence of the style that Matisse and *Les Fauves* (the wild beasts), had developed in Paris a few years before. Fergusson's immersion in the artistic life of Paris, where he was on personal terms with the major figures of the avant-garde and experienced the Russian Ballets of Diaghilev at first hand, led him to formulate, in this and similar pictures, a powerful and highly personal style, far in advance of his British contemporaries.

Very few nudes appear in Fergusson's work before 1910, by which time his interest in still-life as a subject was considerable. Here, though the figure is the dominant element in the composition, it is not a portrait, being as much part of the still-life as the vase of flowers or the pink box. The model's features are simplified and her body is reduced to a rounded, solid form. Thick, dark outlines emphasise her shape and that of each object in the picture. The woman appears to hold the wrapping from the full-blown roses now displayed in the vase. In the centre is a stemmed dish, described as 'Cézannesque' in a contemporary account of Fergusson's studio. A brown lemon, a pink box and a bowl complete the array of foreground objects crowded on the table. A boldly patterned textile, a favourite studio prop of the artist, forms the backdrop. Its close relationship to the woman, indeed the close relationships between all the objects and shapes in the painting, provide the key to Fergusson's intent. Conventional pictorial space has been crowded out of the composition, in favour of a richly decorative surface structure.

George Leslie Hunter
Scottish: 1879-1931

Houseboats at Balloch
Oil on canvas: 76.0 x 63.9 cm.
Presented by Emeritus Professor A.L. Macfie, 1979

Hunter was born in Rothesay. His early artistic career was as an illustrator in San Francisco, after his family had emigrated to California in 1892. An exhibitor with the progressive California Society of Artists, he probably learnt printmaking from the flourishing school of French-inspired landscape painters there. He first visited Paris in 1904, from which date the influence of Steinlen was strong. He returned to Europe for good in 1906 after the destruction of his first one-man exhibition in the famous San Francisco earthquake. He continued his self-education as a painter, while still working as an illustrator to maintain himself. His earlier still-lives are low in tone and reveal his admiration for 17th and 18th century painters like Kalf and Chardin (p. 32), but he gradually absorbed the work of Cézanne, Van Gogh, Gauguin and Matisse, which he studied on repeated visits to France. The late landscapes of McTaggart (p. 48) were also significant for him. He continued painting during the 1914-18 war, while labouring on an uncle's farm in Lanarkshire. Alexander Reid had become his dealer in 1913, and gave him the first of several one-man shows in 1916. He returned for an extended visit to France and Italy in 1922 and adopted a lighter, more intense palette. His subsequent landscapes of Fife, Loch Lomond and the French Riviera were altogether freer and more calligraphic than his earlier work. The French Government recognised his talent when they purchased a Loch Lomond picture from *Les Peintres Ecossais*, an exhibition at the *Galerie Georges Petit*, Paris, in the year of his death.

Houseboats at Balloch, signed but undated, was painted in 1924. Overwork, mental stress and self-neglect appear to have precipitated a severe illness in the early part of 1924. Hunter restricted his travelling, and the late summer and autumn were largely spent painting about the foot of Loch Lomond, a popular Glaswegian retreat for holidays and weekends. Concentrating on the peaceful little bays, cottage gardens and boats was therapeutic, and he worked with renewed enthusiasm and invention. The place held a special attraction for him, and in 1930, the year before he died, he returned to paint a further series.

Houseboats at Balloch is a particularly inventive work. The liquid reflective surface is portrayed with anything but liquid brushwork. It is dry and scrubby and sets up a tension between the reality of the marks and the illusion of the water surface represented by them. The perception of depth is partially denied by the strong outlines of various elements which are read on the surface, the leaning T-shaped awning support on the nearest boat being an example. At the same time the eye is drawn into the depth of the picture by the water rippling directly away from the viewer to the wooded bank beyond. This bank of trees, rising to an apex at the centre of the composition, and reflected in the water below, provides structure to the composition by forming a broad diamond shape within the canvas. Looking in to the depth of the work, the eye is also directed to wander left and right to the limits of the water's surface, encouraging simultaneous perceptions both of the immensity of the loch itself, Britain's largest body of fresh water, and of the cosy huddle of these most unseaworthy craft in the protection of a sheltered mooring.

Francis Campbell Boileau Cadell
Scottish: 1883-1937

Still-Life: The Red Chair
Oil on canvas: 63.5 x 76.0 cm.
Bequeathed by Gilbert Innes, 1971

Cadell, born in Edinburgh, and encouraged by Arthur Melville, first studied at the Royal Scottish Academy School in 1888-9, continuing his training in Paris at the *Académie Julien*, with a foray to Munich (1906-8), before returning to Edinburgh. With Hunter and Peploe he formed part of an informal group later to be called 'The Scottish Colourists'. While he was aware of Impressionism, Post-Impressionism and Fauvism, he was less attracted to the achievements of modern French painters than his colleagues at this early stage in his career, drawing more from the art of Whistler. He visited Venice in 1910, but found the island of Iona (first visited in 1904), the most inspiring alternative to studio work in Edinburgh once war service was complete. At ease in Society, a great deal of his art centred on the fashionable drawing rooms of Edinburgh's New Town, both in still-life and in interiors, depicting fashionable women in elegant light-filled spaces often made intriguing by the use of large mirrors. A renewed appreciation of J.-E. Blanche and Vallotton led, from the 1920s, to the production of further interiors and still-lives in which bold and brilliant flat colour was allied to precise definition of planes and spaces. Despite financial success with many major Scottish patrons, Cadell was not elected a Royal Scottish Academician until 1936. These last years were dogged by illness, and he died of cancer aged 54.

Still Life: The Red Chair, probably painted for the collector Gilbert Innes in 1928, is signed and in its original frame. In the last two decades of his life Cadell painted several still-lives which featured the striking vermilion lacquer chair from which this painting takes its title.

Still-life would be a very limited form of art if its aim was merely copying the appearance of everyday objects. It can prove very inventive, for the artist is free to choose and arrange its elements at will, adjusting lighting and background, until a composition is created worth interpreting in paint. What is the appeal of this painting? It contains only nine objects, none particularly 'beautiful' in themselves. The interest lies in their juxtaposition with each other, in the use of reflected light on the table-top, and in the vibrant contrast of strong colours.

For instance, both the room corner and the wine bottle and its reflection provide a powerful vertical emphasis and a feeling of stability, though the true vertical centre of the painting is craftily understated. The artist has avoided countering this with any strong horizontal emphasis, for only the ellipse of the tea-cup rim emphasises true horizontal. A sense of stability is instead provided by the use of diagonals (in the table edges, the book, the chair back) which 'see-saw' across the picture, balancing each other.

Cadell's use of colour is similarly highly calculated. The principal colours are clearly defined as separate areas of the surface. The 'advancing' red of the chair, set against the 'receding' blues, above and below the table, force the table and its contents out towards us. The overall arrangement of colour is designed to enhance the intensity of each individual area, and thus the enjoyment of pure colour for its own sake.

Stanley Cursiter

Scottish: 1887-1976

Girl with a Pewter Jug

Oil on canvas: 84.6 x 100.0 cm.

Purchased with the aid of the Government's Local Museums Purchase Fund, 1979

Cursiter was born in Kirkwall, Orkney. Lack of funds denied him his ambition to complete training as an architect, and he was then apprenticed to an Edinburgh lithographic printer, studying part-time at Edinburgh College of Art. From 1909 to 1914 he established himself as a designer and painter in a symbolist vein, and was instrumental in introducing Post-Impressionist art to Edinburgh through contact with Fry and Bell in London. A handful of his paintings from this period, convincing interpretations of the Italian Futurist movement, are unique in Scottish art. After the 1914-18 war, during which he made inventive contributions to cartography and radio communications, he became President of the Scottish Society of Artists (1919) and Director of the National Galleries of Scotland (1930-48), undertaking substantial developments and a remodelling only recently removed. Cursiter's varied abilities ~ as painter, designer, lithographer, master of works, radio expert and author of *Peploe* (1947) and *Scottish Art* (1949) ~ ensure his prominence as a significant figure in 20th century Scottish artistic life. Returning to Orkney, he gave up painting in 1962 due to failing capacity, and died at Stromness in 1976.

Girl with a Pewter Jug is signed and dated 1921. A Miss Roberta Farquharson was probably the model. A little earlier, the dealer Aitken Dott had commissioned 20 smaller pictures of pretty girls engaged in similar 'drawing room' activities. Their success led Cursiter to create a more extensive series through the 1920s.

While its creator would have been first to defer to other works in this collection, *Girl with a Pewter Jug* is presently the Gallery's most popular painting. It arrests the attention, appearing to be a dramatic 'snapshot', taken in at a glance. The head of the girl is our immediate focus. She looks directly out of the picture, but not at the viewer; something beyond the viewer's right shoulder has attracted her attention. The theatrical tension of this device is heightened by the strong tonal contrast between the blank black background and the shimmering light on her flesh and blouse, convincingly modelled with a restricted range of whites and pinks. The conventions of pictorial space ~ foreground, middle ground, background ~ are highly compressed. All the elements ~ the girl and the jug she holds, the table and its accoutrements against which she brushes, even the fall of the curtain, broken by the large glass vase ~ lie virtually in the same plane, and at the same depth of our vision. Beyond that lies only an impenetrable blackness.

Underlying what some might dismiss as a rather 'flashy' exercise lies a considerable intelligence. On the one hand, Cursiter was familiar with the European *avant-garde* and its manipulations of accepted pictorial space; indeed he had earlier experimented with the Italian Futurist style. On the other hand, he was a curator and historian, and surely familiar with Chardin's *A Lady taking Tea* (p. 32). The pictorial conventions of both works make an interesting comparison.

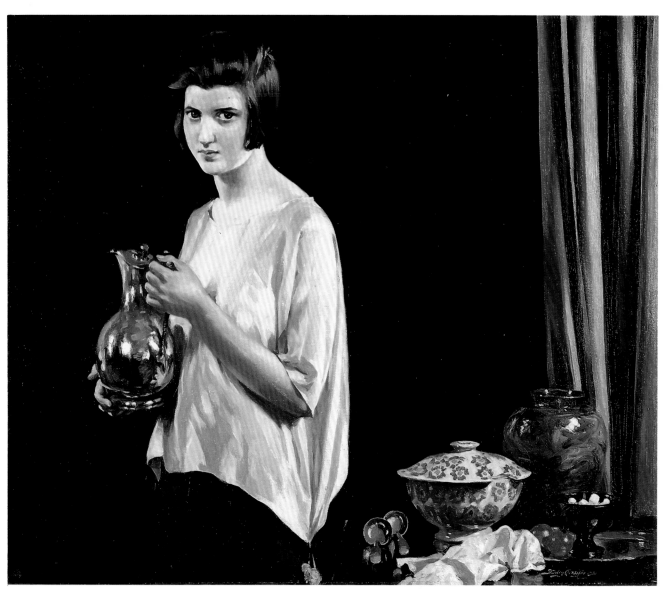

Joan Kathleen Harding Eardley

Scottish: 1921-1963

Salmon Nets and the Sea

Oil on hardboard: 122.0 x 225.0 cm.
Purchased from the artist's estate (Gilbert Innes Fund), 1963

Eardley was born in Warnham, Sussex, enrolling at Goldsmith's College of Art in 1938. After the outbreak of war, the family moved to Bearsden, Glasgow, where Eardley studied at Glasgow School of Art (1940-43), working subsequently as a joiner's labourer until 1945. Post-graduate study, and travels in France and Italy occupied her from 1947 to 1949. She maintained studios in Townhead, Glasgow, in Port Glasgow, in Greenock and at Catterline on the Aberdeenshire coast. The latter she increasingly favoured as a base from the mid 1950s. Her prodigious talent found expression in interpreting the city slum life of young children, in landscape and, in later years, the power of the sea observed at Catterline. Such diverse sources as the late seascapes of Turner, Abstract Expressionism, the graffiti-based art of Dubuffet and the works of Hornel and McTaggart can all be adduced of her work, yet reinforce her unique status. She was elected a Royal Scottish Academician in 1963. Her untimely death that same year at the age of 42 robbed Scottish art of one of its greatest modern talents.

Salmon Nets and the Sea, signed and dated 1960, was painted at Catterline, a small fishing village on the Aberdeenshire coast. Joan Eardley first visited Catterline in 1951, and was immediately attracted by its crescent-shaped harbour, rocky promontory and row of cottages perched above the cliff. By 1958 she was exhibiting pictures of the winter sea, painted with great power and realism in the face of fierce winds and driving rain. The large sheets of board (this is one of the largest) were clamped to the easel, which was weighted with rocks. In her letters she wrote with excitement of the constantly changing conditions: "the sea is all whiteness...the bay is all foam."

Salmon were caught in bag nets, anchored about 50 yards off-shore. At Catterline in 1962 there were five salmon fishermen involved, but fishing ceased in 1974 due to poor catches. This work was painted on the 'makin' green', an area of grass under the headland where the nets were hoisted up by pulleys to dry on lines strung between a 'net-berth' of tall larch poles. The outlines of the nets are faintly drawn, stretched out to posts in the centre. The rectangular form intersected with diagonals, on the left, and the crane-like features outlined against the sky, appear to be other net-drying structures. A cart, to transport the nets, lies at the edge of the shingle.

The surface is richly coloured and intensely worked, scratched and textured with sand worked into the paint. Thickly applied, allowed to drip, the paint is dragged across in broad strokes to express the energy in the waves lashing the rocks, breaking into white foam and spray and whipping up the net ropes. To the right the dark heavy sky and sea threaten a worsening of the storm.

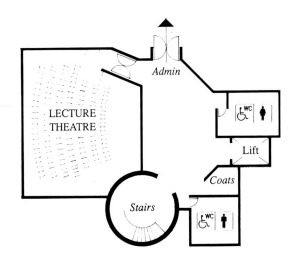

BASEMENT

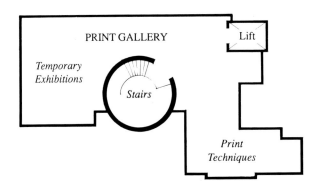

FIRST FLOOR